# How to
## Draw and Paint
# Fairies

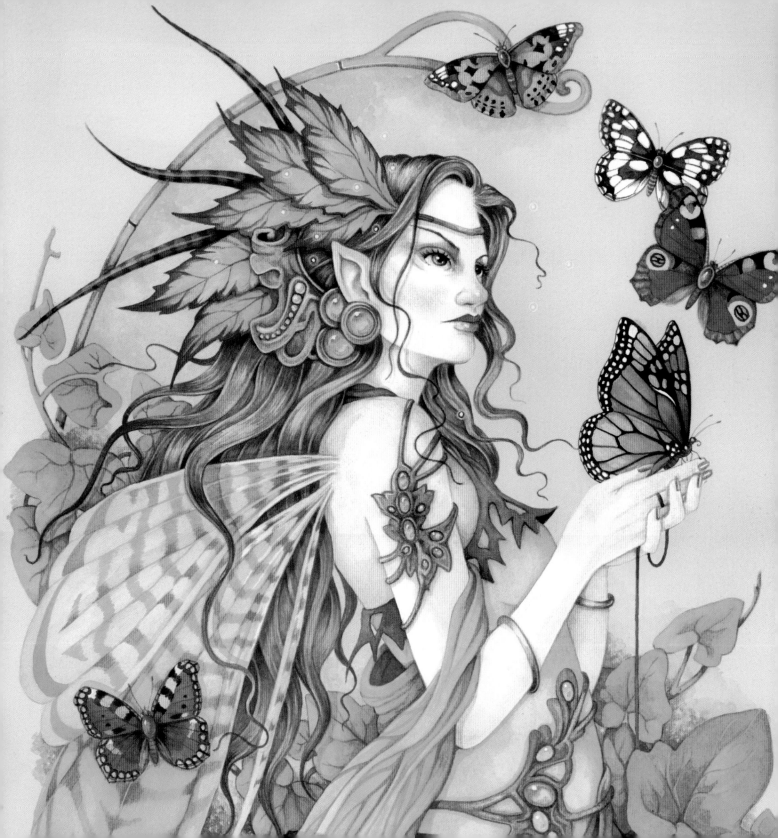

# How to
# Draw and Paint
# Fairies

✱ From finding inspiration to capturing diaphanous detail

✱ A step-by-step guide to fairy art

## Linda Ravenscroft

WATSON-GUPTILL PUBLICATIONS

NEW YORK

A QUARTO BOOK
Copyright © 2005 Quarto Inc.

First published in the United States in 2005 by
Watson-Guptill Publications, Nielsen Business Media,
a division of The Nielsen Company,
770 Broadway, New York, NY 10003
www.watsonguptill.com

Library of Congress Catalog Card Number: 2005927671

ISBN 0 8230 2383 4

QUAR.FRP

Conceived, designed, and produced by
Quarto Publishing plc
The Old Brewery
6 Blundell Street
London N7 9BH

Project editor: Susie May
Art editor/designer: Jill Mumford
Picture researcher: Claudia Tate
Copy editor: Hazel Harrison
Proofreaders: Robert Harries and Meryl Greenblatt
Assistant art director: Penny Cobb
Editorial Assistant: Mary Groom

Art director: Moira Clinch
Publisher: Paul Carslake

Color reproduction by PICA Digital, Singapore
Printed in China by SNP Leefung Printers Ltd

5  6  7  8  9 / 12  11  10  09  08  07

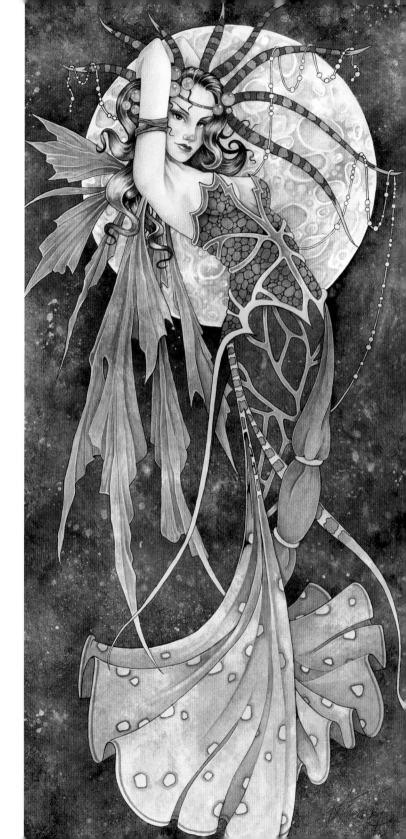

# CONTENTS

# INTRODUCTION

There are few more delightful subjects than fairies, but they do offer a unique challenge. How do you draw and paint something you can't see? But in fact fairies are not that hard to conceptualize, as they are closely based on the human figure, especially children, while wings—their main magical attribute—can be taken from a number of sources, such as leaf forms or the wings of birds and butterflies.

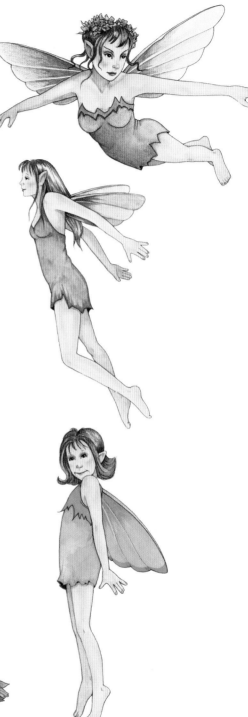

This book aims to start you on your way to becoming a fairy artist by offering a wealth of ideas as well as a series of "templates" of fairy faces and figures for you to trace or copy. It is divided into three main technical chapters, the first dealing with the tools and materials you can use for your paintings, and the second showing easy ways of creating basic fairy shapes and forms. This chapter also includes a unique series of "swipe file" pages, with illustrations of fairy hairstyles and headdresses, fashions, and the all-important wings, so you can choose how you will dress these nature-loving but fashion-conscious creatures.

The third chapter is devoted to the methods used to depict fairies and their habitats, and covers a wide range of exciting techniques for achieving magical effects. Interspersed with these pages are four full-color step-by-step demonstrations showing fairies associated with each of the four seasons, a common theme in fairy art. You can copy these if you wish, or use them as a springboard for your own ideas.

Finally, after mastering the techniques of the first three chapters, Chapter Four gives you some ideas for developing the personalities of the fairies you wish to depict.

## FINDING INSPIRATION

Since fairies are creatures of nature, the natural world offers a wealth of inspiration, and a simple stroll through the countryside can offer endless ideas for your fairies' attributes and habitats. Look closely at plants and flowers, and investigate objects like old tree roots, trying to imagine little doorways leading into the fairies' homes. Think about what life would be like as a fairy —how would you live, what clothes would you wear?

*Photograph fairies whenever possible.*

*Sometimes you can find butterfly wings.*

*Foxgloves make excellent hats.*

Make sketches and take photographs whenever possible, and also try making collections of small objects such as fallen leaves, pieces of bark, snail shells, patterned stones, crystals, and so on. Another useful source, especially for wings, is dead insects. You can sometimes find dragonflies and butterflies that have died naturally and become desiccated, leaving their wings and bodies intact. They are very fragile, and need to be handled with great care, but they present an excellent opportunity to study the structure and details of wings at close quarters.

If you don't have easy access to fields and woodlands, botanical books provide an excellent source of ideas for plants, flowers, and insect wings—many fairies' wings are based on those of butterflies, birds, or insects. For flowers, gardening magazines and catalogs are useful, as they often feature exotic blooms that you might not otherwise find, and the photography is usually of a high standard.

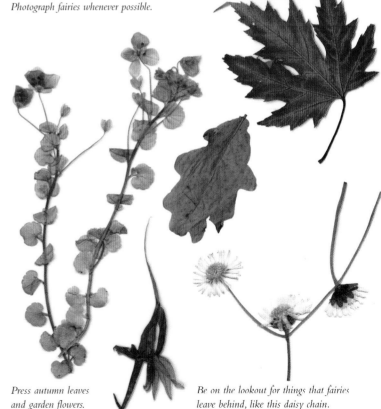

*Press autumn leaves and garden flowers.*

*Be on the lookout for things that fairies leave behind, like this daisy chain.*

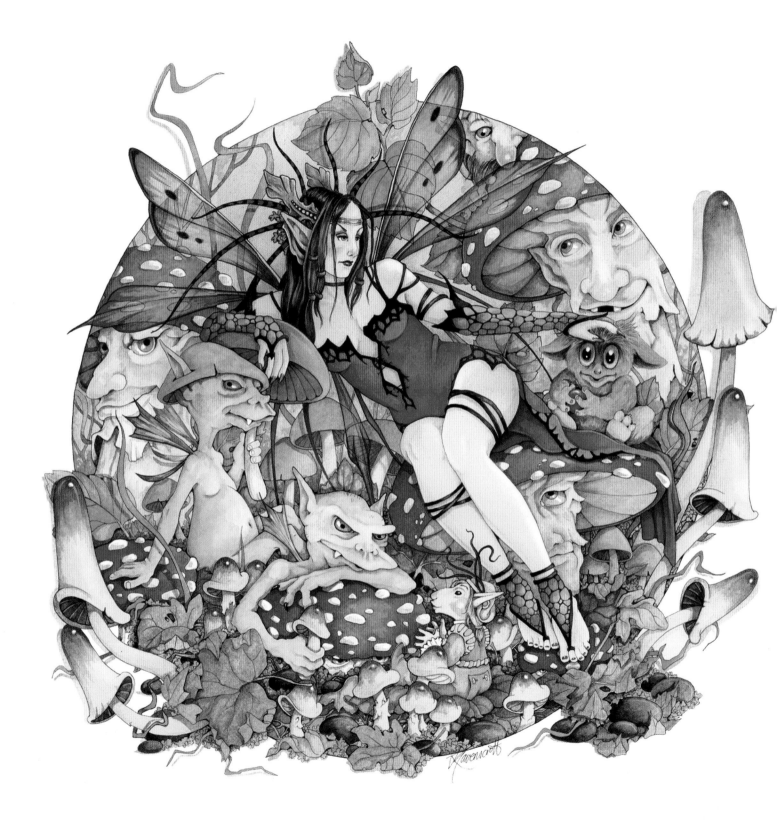

Chapter One

# GETTING STARTED

# PENCILS AND GRAPHITE

The first requirement for any artist is a good range of pencils. You will need an all-rounder such as an HB or B for making preliminary drawings for your fairy paintings, but a wider range will enable you to make more meaningful outdoor sketches as well as try out ideas for compositions.

    The softer pencils allow you to build up tone as well as line, so they can be used either over or under watercolor washes for shading, perhaps on the body of a fairy or on additional features such as trees.

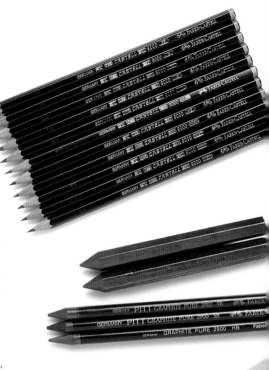

## GRADES OF PENCIL

Pencils are made in different grades, and are marked with a number and letter classification, with "B" standing for black and "H" for hard. The higher the number the softer or harder the pencil, with 9B being very soft indeed. A recommended range of pencils is HB, B, 2B, 4B, and perhaps 6B or 8B if you like to use dark tones in your drawings—but bear in mind that very soft pencils smudge easily.

## GRAPHITE STICKS

These are simply graphite without the outer casing of wood, and are thicker than normal pencils. They are useful for broad areas of tone, as they can be used on their sides like pastels (see page 16), but they are not designed for detail or fine line work. They are also graded for relative softness.

## ERASERS

These are essential for making corrections. The best erasers are the flexible white plastic ones that remove marks cleanly without abrading the paper.

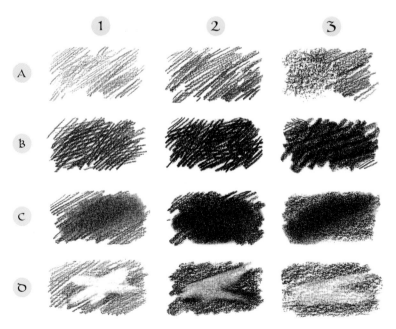

### 1. MEDIUM SOFT PENCIL (2B)

For sketching and trying out ideas, a 2B pencil is ideal, as it combines flexibility with a sympathetic, soft mark. However, it is too dark for making preliminary drawings for paintings unless you want the pencil to show through. HB pencils are best used for these.

### 2. SOFT PENCIL (6B)

These are ideal for making really dark marks and building up solid areas of near-black. They smudge easily, so keep your hand off your drawing or protect it with a piece of spare paper.

### 3. GRAPHITE STICK

Graphite stick is the tool for covering large surfaces quickly. Some graphite sticks are lacquered to keep your hands clean, but it is better to buy the uncoated types, as these allow fast sideway use.

KEY: A. NORMAL PRESSURE
      B. CROSSHATCHING
      C. BLENDING
      D. USING THE ERASER

# WATERCOLORS

Watercolors are especially well suited to fairy paintings because of their delicate translucent quality, but they are also highly versatile, and can be applied in various ways from thin, wet washes to areas of solid, brilliant color and fine linear detail.

## WATERCOLOR CHOICES

Watercolors are made in tubes and flat pans, so the first choice to make is which to buy. Pans are designed to fit into a paint box with a built-in palette for mixing, and are thus more convenient for outdoor work, but apart from that the choice is a personal one. If you want to use strong paint for more opaque techniques, tubes are better, as you can squeeze out the creamy paint and apply it with the minimum of dilution, while pans have to be rubbed quite hard with a wet brush to release strong color. Pans in a paint box get dirty through the process of color mixing, requiring regular cleaning, but with tubes you can simply squeeze out small amounts of color as needed. Any that is left over on the palette at the end of a working session can be reused, as all watercolors contain gum arabic to keep them moist.

## CHOOSING COLORS

You can buy paint boxes complete with pans or tubes of paint, but you do run the risk of not having the colors you need, so it is usually better to buy colors individually, starting with a fairly small range and building up gradually. The standard palette on page 25 will make an adequate starter set, but you may find you need some "special" colors such as rose madder and magenta for painting flowers, as these are always more brilliant than mixtures of other colors. They are also more expensive, as paints are priced according to the relative cost of the pigments used to make them.

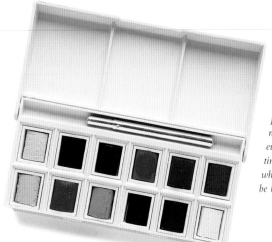

PAINTBOXES
*Most of the ready-made paintboxes contain half-pans rather than whole pans, but even these last for quite a long time. They can be replaced when finished, as all colors can be bought individually.*

PANS AND HALF-PANS
*Artists who work on a large scale usually prefer to use whole pans, but the smaller size is adequate for most purposes.*

ARTISTS' COLORS
*A selection of tubed artists' colors. These are made in standard sizes, which may look small in comparison with oils or acrylics, but actually last a very long time.*

## ADDITIONAL EQUIPMENT

Apart from brushes and palettes, shown on page 18, you need very little else, but masking fluid is an essential extra, as it enables you to reserve small or intricate areas of white without having to paint laboriously around them. Soft kitchen towels are useful for cleaning up, and can also be used for lifting-out methods, but if you don't want the texture to show in the artwork, use tissues or toilet paper instead. Small sponges are most often used for making corrections and lifting out, but you can also apply paint with them. Gummed-paper tape is used for stretching paper (see page 21).

# Colored pencils

Most people will be familiar with colored pencils, and have probably used them in childhood, which is perhaps why they do not get the attention they deserve. But the inexpensive pencils supplied by schools or given as presents are a very different matter from those made for artists and illustrators. These are a pleasure to work with, and because using pencils comes more naturally than working with brushes, they are one of the easiest mediums to try out.

## CHOOSING COLORED PENCILS

Colored pencils can't be premixed on a palette as paints are, and thus are made in a vast range of colors, but you won't need more than about ten to make a start, especially if you intend to combine them with watercolors, so the best course would be to buy a small starter set and add more colors as needed. Most prepacked sets contain a suitable basic color range.

There are different types of colored pencils, some being waxy and slightly water resistant, creating a rich, smooth stroke that is difficult to smudge. The leads in these pencils can be sharpened to a very fine point, enabling the artist to draw in fine detail, but they are not as good for blending as the chalkier type of pencil. The latter can be used to create some lovely soft, dreamy effects, perfect for fairies. You can mix colors by overlaying with other shades, using a cotton swab, paper stump, or small piece of tissue to blend colors and smooth out the lines.

Whichever type of pencil you choose, it is recommended that that you purchase a good-quality sharpener to keep the pencil tips in good order, and always spray completed pieces with a suitable fixative spray to stop any unwanted smudging.

### TYPES OF COLORED PENCILS

*1. Chalk pencils have a velvety texture and are easy to blend.*

*2. The softer wax pencils create subtle effects of shading and color gradation.*

*3. Water-soluble pencils can be used wet and dry, providing a high degree of textural variation.*

*4. Harder wax pencils are good for line work, hatching, and shading.*

*5. Hard pencils with fine leads are well suited to intricate detail.*

# USING COLORED PENCILS

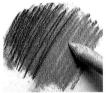

### MIXING COLORS
*Colors can be mixed or modified either by blending or by overlaying, using the traditional method of crosshatching.*

### BLENDING FLAT COLORS
*Lay down the colors as solidly as possible, using close shading lines, then use a blending implement to soften the transition from one color to the next.*

### BLENDING WAXY PENCILS
*To blend waxy pencils, it is necessary to work one color into another, as they can't easily be rubbed together.*

### BLENDING CHALKY PENCILS
*Lay down lines quite close to one another and rub them into one another with a paper stump, a cotton swab, or your fingers.*

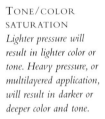
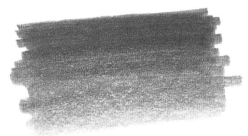
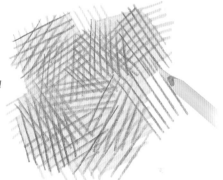

### TONE/COLOR SATURATION
*Lighter pressure will result in lighter color or tone. Heavy pressure, or multilayered application, will result in darker or deeper color and tone.*

### OPTICAL MIXING
*Colors placed close to each other will mix optically when viewed from a distance. Blue hatched over yellow will appear as a green.*

## WATERCOLOR PENCILS

These are a marvelous invention, as they can be applied just like ordinary colored pencils and then brushed over with water to form a wash, which makes it easy to blend colors. They are suited to artists of all skill levels, but are especially recommended for those who have never used watercolors and are perhaps a little nervous about trying them, although there are some watercolor effects that can't be achieved with these colors. For example, you can't lay a true flat wash because the pencil marks will still show, and adding too much water may give a chalky, patchy appearance. It is best to make a virtue of the linear element and use watercolor for any large areas such as skies and backgrounds, perhaps bringing in a little watercolor pencil on top.

### WATER-SOLUBLE PENCILS
*Water-soluble pencils can be used both dry and wet. They are quick and clean to use, and light and easy to carry.*

## WATERCOLOR CRAYONS

Also available are watercolor sticks, or crayons, which behave in a similar way to the pencils but are better for large areas of work. Like watercolor pencils, these are available in pre-packaged sets of various sizes or can be bought singly. Since they are made in a fairly wide range of colors, it would be wise to purchase a beginners' set to start with and add to your collection at a later date.

### WATER-SOLUBLE CRAYONS
*These crayons have a slightly waxy texture, and handle more like oil pastels (see page 17) than colored pencils, but can be mixed with water in the same way as the pencils. This gives considerable scope for blending and mixing on the paper surface.*

# GOUACHE AND ACRYLIC

People often ask what the difference is between watercolor and gouache. The answer is that gouache is the opaque version of watercolor, and the two are often used together in one painting. Gouache can be used thinly to lay washes in the same way as watercolor, but it tends to give a slightly more chalky appearance depending on the colors used, because the lighter tones are obtained by adding white pigment.

## USING GOUACHE

Paintings in which gouache and watercolor are combined are usually begun with the latter, with the opaque paint used thickly for highlights, as in many of the demonstrations in this book. However, some artists use gouache rather like oil paint or acrylic, using it thickly throughout and working from dark to light. Because the paint is basically opaque, the colors don't run into each other as readily as do watercolors, and even quite thick layers can be painted over when dry—though take care here, as new applications should not be too wet or they will disturb the paint below.

Gouache is also great for painting over acrylic, creating a nice matt finish that reduces the natural sheen of the acrylic and gives a three-dimensional look.

## ACRYLIC

Acrylic paints are unique in that although they are water based, and diluted with water, they are impermeable once dry. This is because the pigments are bound with a polymer resin, a form of plastic. This has in the past led some artists to denigrate acrylics, referring to them as "plastic paints," but those who use them regularly appreciate their quality and their amazing versatility.

**GOUACHE PAINTS**
*Gouache paints are usually supplied in tubes, about twice the size of watercolor tubes. As with watercolors, there is a wonderful array of colors to choose from— even metallic and iridescent colors, which are marvelous for special effects on wings, or for creating sparkles on jewelry. One of the disadvantages of gouache is that the tubes tend to dry out over time, so don't buy more than you are sure you will need.*

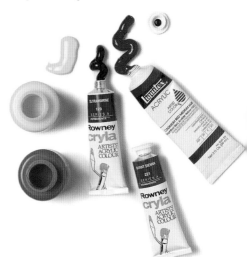

**STUDENTS' AND ARTISTS' COLORS**
*Like most paints, acrylics are produced in students' and artists' versions. The students' colors contain less pure pigment, but are perfectly adequate as an introduction to the medium. Artists' colors vary in price depending on the manufacturer and the pigment used. Some pigments are much more expensive than others. Students' colors are all priced the same.*

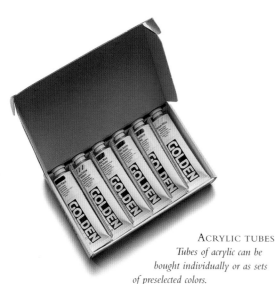

**ACRYLIC TUBES**
*Tubes of acrylic can be bought individually or as sets of preselected colors.*

**JARS AND BOTTLES**
*Acrylic is sold in jars and bottles as in well as tubes, with the paint usually being slightly more fluid. If using jars, avoid dipping brushes directly into them unless they are perfectly clean, or you will dirty the color.*

# USING ACRYLICS

Straight from the tube, acrylics have a consistency similar to oil paints, and can be used in much the same way, but they can also be applied as thin washes, or glazes, which provides an excellent way of building up rich colors. For glazing techniques, their fast drying time is an advantage, as is the fact that they are waterproof once dry, but for methods like blending you may need to add a retarding medium to keep the paint moist for longer. Many other mediums are available for acrylic work, such as impasto mediums, which bulk out the paint; matt and gloss painting mediums, sold in bottles, both of which thin the paint and increase its transparency; and various mediums for adding texture to the paint. You can also combine acrylics with almost any painting or drawing medium (except oil paints), drawing over them with pastels, oil pastels, or pencils, and painting over them with gouache or watercolor.

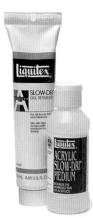

### RETARDING MEDIUMS
*The rapid drying time of acrylic paint can be slowed by adding a retarding medium. This type of medium simply slows the evaporation of water from the paint, keeping it workable for longer. Be careful not to use too much, though, otherwise the paint will become sticky.*

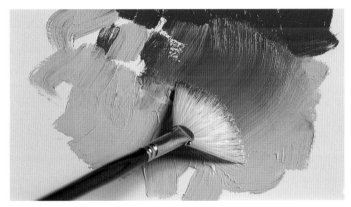

### STRAIGHT FROM THE TUBE
*Acrylic paint of a buttery consistency is perfect for spontaneous painting techniques.*

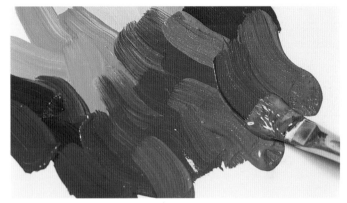

### BLENDING
*Acrylic paint must be blended quickly, before it dries.*

## KEEPING THE PAINT MOIST

Acrylic dries very quickly when it is squeezed out onto a normal palette, but this problem can be overcome either by spraying regularly with water, using a plant sprayer, or by purchasing a special "reservoir" palette, which is designed for the purpose.

These palettes are packs of two different papers, an absorbent one that is placed in the bottom of the tray and well wetted, and a membrane that is placed on top. The paints are squeezed out onto the membrane, and enough water seeps up to keep them moist. The clear lid is replaced after a working session, keeping the paint wet for days or even weeks.

# PASTELS AND PASTEL PENCILS

Pastels and pastel pencils are both made of the same materials, the main difference being that the pencils are a thin stick of pastel "wrapped" in wood, just like a graphite pencil. They are slightly harder than soft pastel sticks but softer than colored pencils.

## TYPES OF PASTEL

All pastels are made by mixing pure pigment with an extender such as French chalk, which is then bound with a gum medium. The harder types of pastel, which are normally square shaped, contain more binder, while the soft ones are almost pure pigment, yielding wonderfully rich colors but breaking and crumbling very easily. Soft pastels are usually round shaped, wrapped in paper to protect your hands, and are made in different thicknesses according to the manufacturer. They can all be bought singly or as boxed sets.

## USING PASTELS

Even the harder types of pastel and pastel pencils are easily blended together using a cotton swab, a paper stump, or your finger, enabling you to mix colors on the paper surface, but bear in mind that they smudge easily. A wise precaution is to cover any completed area with a clean piece of paper, especially if it is at the bottom of the drawing, where your hand rests. And unless you can frame your finished work immediately, it should be sprayed with "working," or temporary fixative to protect it. Fixative can also be used in the course of a drawing so that you can build up colors without disturbing or mixing with previous ones.

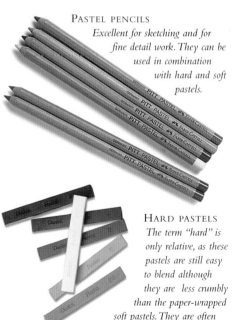

### NARROW SOFT PASTELS
*These are very soft, but are good for detail, as you can draw quite fine, sharp lines with the edge of the stick. They can be broken into short lengths for side strokes covering large areas.*

### CHUNKY SOFT PASTELS
*These are perfect for covering large areas, but are not as good for detail or fine work. They can be used in combination with pastel pencils.*

### PASTEL PENCILS
*Excellent for sketching and for fine detail work. They can be used in combination with hard and soft pastels.*

### HARD PASTELS
*The term "hard" is only relative, as these pastels are still easy to blend although they are less crumbly than the paper-wrapped soft pastels. They are often used in the early stages of a drawing to block in the main colors, as they don't fill the grain of the paper as quickly as soft pastels.*

### LINEAR STROKES
*Making a stroke using the square end of a hard pastel gives a bold, thick line.*

### SIDE STROKES
*Using a hard or soft pastel on its side makes a broad area of color. This usually necessitates breaking the pastel stick in half or into even smaller sections.*

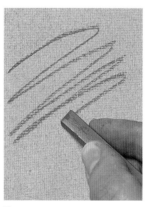

### FINE LINES
*The sharp corner of the stick gives a finer, more delicate line. A similar effect can be achieved with small soft pastels.*

# Oil Pastels

Oil pastels look a little like soft pastels, being made in stick form, but there the resemblance ends, as they are very different to use. Like all paints and color drawing media, their primary constituent is pigment, but they are bound with oil and wax, which makes the texture dense and greasy and the colors slightly less opaque than soft pastels.

## Using oil pastels

Because of the oily quality, these pastels tend to fill the grain of the paper quite quickly, which limits the amount of layers you can build up. However, colors can be mixed by applying them lightly over one another, and they can also be "melted" and spread out with turpentine or mineral spirits and a brush or rag so that they become more like paint. This is a useful method for blending, as oil pastels cannot easily be rubbed together with a finger or blending implement. One of their great advantages is that they require no fixative, and can thus be stored without the risk of smudging.

They are very versatile and can be used on a number of surfaces, even shiny ones like plastic. They can also be used over watercolor and acrylic, and are useful for wax resist methods as well as sgraffito techniques (see page 90)—the latter is a method especially associated with oil pastels.

### Boxed sets

*Oil pastels can be bought as boxed sets, a good way to start if you are new to the medium. The more expensive brands of oil pastel come in wide color ranges and can be bought individually at most good art stores.*

### Iridescent oil pastels

*These are a recent addition to the oil pastel range, and can create lovely effects, ideal for wings or to create shimmering backgrounds. Try using them over acrylic washes.*

### Sgraffito

*In this example, several oil pastel colors have been laid over one another and a sharp blade used to scratch through the top layer to reveal colors beneath. You need a fairly sturdy, smooth paper for this method, and the color must be applied heavily.*

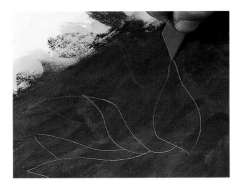

### Blending with spirit

*Here you can see the effect of working into oil pastel with a brush dipped in turpentine. Mineral spirits can also be used, but is not advisable if you are working on paper, as the spirits may cause deterioration over time.*

## Wax crayons

These share some qualities with oil pastels, and can also be used for wax resist methods. Inexpensive children's crayons are adequate for resists, but for anything else it is important to use a good-quality crayon, so look for those that contain beeswax and have a high pigment content. Even these are relatively inexpensive compared with other media.

### Wetting the surface

*If the surface is first wetted with turpentine or mineral spirits, the pastel will glide over it, and the colors can be easily blended while still wet.*

# BRUSHES AND PALETTES

There are many different ranges of brushes made for use with all types of paints and inks, and since some of them can be very expensive, it is best to start with a small range. For watercolor work three brushes in different sizes will be adequate, though you may need more for acrylic. The two main brush shapes are rounds and flats. Rounds are the most versatile, though some watercolor painters prefer flats for washes and dry-brush methods (see page 80).

## BRUSH CHOICES

The best watercolor brushes are sables, but there are many excellent synthetic alternatives, as well as sable and synthetic mixtures. These can also be used for both inks and acrylics as long as they are rinsed out well after use, though there are ranges of brushes designed especially for acrylic work, made from ox hair, bristle, or synthetic materials.

For fine lines such as tree twigs and grasses, you might like to try a rigger brush, so-called because it was originally used by marine artists to paint rigging. These have much longer hairs than normal brushes and can be used on their sides as well as their points. Inexpensive decorators' bristle brushes and children's paintbrushes are useful for effects such as stippling, dry brush, and some acrylic methods, while old toothbrushes are essential for watercolor and gouache spattering methods (see page 91).

## PALETTES

There is a large range of palettes available for watercolor, acrylic, and ink, made from either plastic or ceramic. Plastic palettes are not suitable for acrylic or acrylic ink as any leftover color is impossible to remove. Acrylic is best mixed on disposable paper plates or in the stay-wet palette shown on page 15.

**BRUSH SIZES**
*Brushes are sized from No. 00, the smallest, to 14 or even larger. The selection of rounds shown here runs from No. 00 to No. 12.*

**RIGGER BRUSHES**
*These are ideal for painting long, straight lines, which are hard to achieve with the point of a round brush. Shown here, from top to bottom, is a medium and a large rigger. These brushes are sometimes called "stripers."*

**FLAT BRUSHES**
*Flat brushes are chisel shaped and held in flat ferrules, and are good for washes and for broad lines. The long-haired brushes hold enough extra paint to make one continuous stroke across the paper.*

**NYLON BRUSHES**
*These are made specifically for acrylic work, and are tough, hard wearing, and springy.*

**CHINESE BRUSHES**
*These are now becoming widely available, and because they are considerably less expensive than most watercolor brushes, are well worth trying. They can create a wide variety of different marks.*

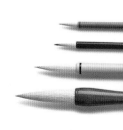

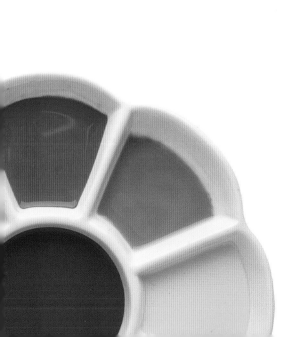

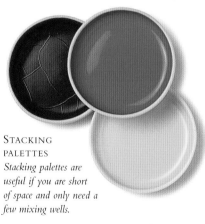

**STACKING PALETTES**
*Stacking palettes are useful if you are short of space and only need a few mixing wells.*

**FLOWER-SHAPED CERAMIC PALETTES**
*Flower-shaped ceramic palettes are a popular choice for watercolor work, as they have deep wells for mixing.*

# PEN AND INK

Pen and ink is a wonderfully responsive medium, and ideal for delicate subjects like fairies. In this context, however, it is most often used in combination with watercolor, as you will naturally want to show your fairies and their floral or woodland environments in full color.

## TYPES OF PENS

Drawing pens fall into two main categories: dip pens with interchangeable nibs, and reservoir pens, which contain their own ink, and are made in a range of colors. Fiber-tipped pens, ballpoint pens, markers, and brush pens all fall within the second category, but there is a further subdivision, as some contain waterproof inks while others are water soluble. Waterproof-ink pens are usually chosen for line and wash methods, but you can achieve attractive and subtle effects with water-soluble inks, as the lines will spread and soften when the wet paint is applied.

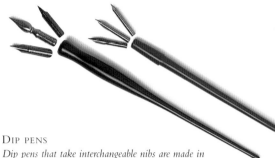

### DIP PENS
*Dip pens that take interchangeable nibs are made in both wood and plastic. A wide range of nibs is available, but not all fit into every pen holder, so it is best to purchase both together.*

### BALLPOINTS, ROLLERBALLS, FIBER-TIPS, AND MARKERS
*The range of these pens is huge today, and although they are available only in a limited nib size, they are very useful drawing implements. Rollerballs tend to be slightly "wetter" than ballpoints.*

### BRUSH PENS
*These are a relatively now product. They have flexible, brushlike nylon tips that produce fluid, calligraphic strokes.*

### RESERVOIR PENS
*Resembling traditional fountain pens, these hold a cartridge that delivers a steady flow of ink to the nib. They are available with nibs of different sizes and shapes, giving a range of line thicknesses. These pens can be used for drawing, but should only be used with watersoluble inks. They are easy, clean, and convenient to use.*

## INKS

If you are using dip pens you have a wide choice of different inks, again some being waterproof and others water soluble. Both can be diluted with water to produce paler tones, and can be applied with brushes as well as pens. If you only intend to use pen and ink for line drawing, you won't need more than one or two bottles. Sepia is a color much favored by fairy artists, as it produces a softer effect than black.

### FIBER-TIPPED PEN SETS
*These can be bought in sets or individually, and a variety of different point sizes is available.*

### ACRYLIC INKS
*These, made in a variety of colors and waterproof when dry, are excellent for either line and wash methods or complete paintings. The pearlescent inks shown to the left would be ideal for fairies' wings and other shimmer effects.*

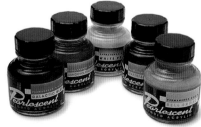

# Paper

The surface you work on makes a good deal of difference to the success of your paintings and drawings, and also to your enjoyment of the process. There is nothing more frustrating than discovering that the paper is too smooth to hold pastel color or too rough to allow you to build up the detail you need in a colored-pencil drawing.

## Drawing and pastel papers

For drawing and sketching, and for colored pencil or pen and ink work, the usual choice is smooth-surfaced drawing paper, though some artists prefer textured paper for colored pencil (see page 12).

Pastels require a textured surface, or "tooth," to hold the powdery pigment in place. The most widely available papers are Ingres and Mi-Teintes, the first having a texture of straight lines and the second one that resembles fine chicken wire. This paper is effectively two papers in one, as you can also use the smooth side, which still has enough texture to hold the pigment.

Pastel papers are made in a wide range of colors, as it is not usual to work on white paper. This is because small flecks of white showing through the applied colors can be jumpy and disturbing. Colored paper also allows you to leave certain areas bare to stand as a color in their own right; for example, you might choose a creamy color or a warm beige to act as the light or middle tone on a fairy's face or body, or work on a blue-gray paper and leave it uncovered for the sky.

## Watercolor papers

Watercolor papers, which can also be used for acrylic, are made in three different textures: hot-pressed (smooth), cold-pressed (medium), and rough. Cold-pressed is the all-around favorite, and has been used for the majority of the demonstrations in this book.

Papers can be bought as single large sheets that can be cut to size, or in pad or block form. The blocks are useful, as the paper is sealed all around the edges of the pad, preventing it from moving and losing its shape when paint is applied.

Whether in loose sheet or block form, watercolor paper is made in different weights, or thicknesses, which are expressed in lbs, referring to the weight of a ream of paper (500 sheets). The heaviest ones are about 300 lbs, while most sketchpads contain 140-lb paper. This is just thick enough to prevent buckling when paint is applied, but lighter paper will need to be stretched before painting, as shown opposite.

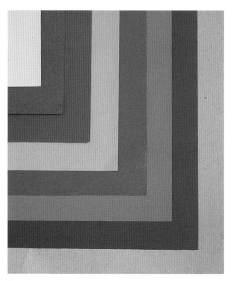

PASTEL PAPERS: BRIGHT COLORS
*Vivid or densely saturated colors make a strong impact, but could be a little overpowering for fairy subjects.*

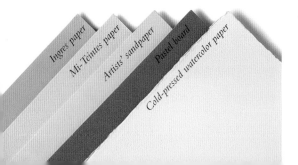

Ingres paper
Mi-Teintes paper
Artists' sandpaper
Pastel board
Cold-pressed watercolor paper

PAPER TEXTURE
*You will have to experiment to find out which texture you like for pastel or colored pencil work. The lines on Ingres paper show through unless the pastel or pencil is heavily applied. Some people find the texture of Mi-Teintes paper over-obtrusive, but it can add interest to your work. The "wrong" side of the same paper gives a less mechanical effect.*

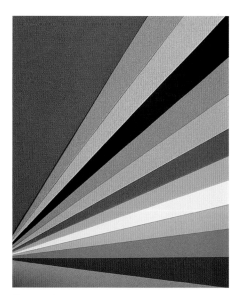

PASTEL PAPERS: NEUTRAL TINTS
*Beige, buff, and gray papers provide a mid-tone that can be either warm or cool. Black is a bold choice, but can give exciting results.*

*Cold-pressed paper*

*Hot-pressed paper*

*Rough paper*

## DIFFERENT WATERCOLOR PAPERS

*As you can see from these swatches, the paper texture has an effect on the way the paint behaves. On rough paper (above) the paint sits on the surface and breaks up the brushstrokes; on hot-pressed paper (middle) it glides over the surface but tends to puddle, while cold-pressed paper (top) has enough texture to hold it in place.*

## STRETCHING PAPER

Stretching paper is not at all difficult, but you do need to remember to do it well in advance, as it takes some time to dry. It's well worth the effort, as it means you can economize by buying lightweight paper.

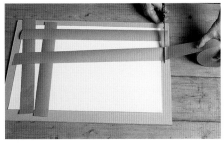

1. When you have chosen your paper size, cut four strips of gummed-paper tape approximately 2 inches longer for each side.

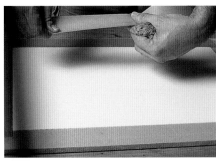

2. Starting on the longest side, wet a length of tape with the sponge and lay it along the edge, with about one third of the tape covering the paper.

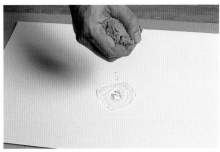

3. Either soak the paper in a bath and pick it up by one corner to allow the excess to drain off, or lay it on the board and wet it by squeezing out water from a sponge.

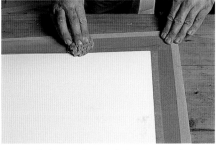

4. Smooth the tape down with the sponge and repeat the process for the other sides. Leave the paper to dry naturally.

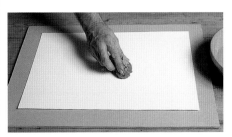

5. Wipe away any excess water with the sponge, taking care not to distress the paper surface.

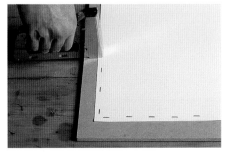

## QUICK STRETCHING METHOD

*If you are in a hurry, you can use staples to secure the paper to the board, wetting the paper first and working quickly before it has begun to dry out.*

# Understanding Color

The ability to mix color to the right shades is mainly something that comes with experience and practice, but it is helpful to know a little about the properties of colors, to achieve successful mixtures and to create atmosphere in your paintings.

## Primary and secondary colors

Most of us know that red, yellow, and blue are primary colors—so called because they can't be made by mixing other colors—and that mixtures of any two of these create a secondary color—orange, green, and violet. But there is more than one version of each primary color, so for successful color mixing you need six primaries, not just three.

Most artists have their own favorite colors that they would find it hard to do without, but for beginners it is best to start with a fairly small range and discover what colors can be mixed from them.

## Complementary colors

Complementary colors are those opposite one another on the wheel. There are three pairs: red and green, blue and orange, and yellow and violet. Each pair consists of one primary and one secondary color. When combining these, you are in effect mixing three primary colors. However, unlike some three-color mixes, the complementaries cancel one another out, producing muted neutrals.

Complementary contrasts can be used in a painting to produce very vibrant effects—a few bright red berries among foliage, for example, will bring the green to life, and you might try touches of orange on a blue gown to give extra interest to a fairy's clothing.

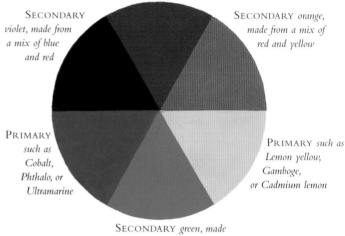

PRIMARY *such as Alizarin crimson, Cadmium red, or Permanent rose*

SECONDARY *violet, made from a mix of blue and red*

SECONDARY *orange, made from a mix of red and yellow*

PRIMARY *such as Cobalt, Phthalo, or Ultramarine*

PRIMARY *such as Lemon yellow, Gamboge, or Cadmium lemon*

SECONDARY *green, made from a mix of yellow and blue*

COLOR WHEEL
*The color wheel is a clever arrangement of colors that shows some basic aspects of color theory. Between each of the primary colors is the secondary color achieved by mixing them together. The colors opposite each other on the wheel are complementary pairs.*

## Tertiary colors

Tertiary colors are produced by mixing a primary color with a secondary color. If a primary is mixed with the secondary next to it on the color wheel, the result is usually a harmonious blend of the two colors. If a primary is mixed with the secondary opposite it on the color wheel, a more neutral color (brown or gray) is likely to result. As with the secondary colors, a huge range can be achieved by varying the proportions. Although most starter palettes contain two or three tertiary colors, it is good practice—and fun—to try mixing your own.

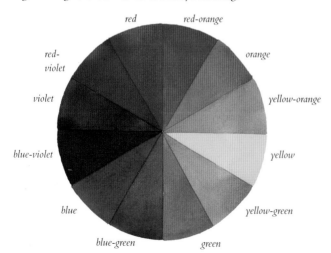

red
red-orange
red-violet
orange
violet
yellow-orange
blue-violet
yellow
blue
yellow-green
blue-green
green

◀ TERTIARY COLOR WHEEL
*This wheel shows primary, secondary, and tertiary colors of pigment. The teriary colors are produced by mixing a primary color with the secondary color nearest to it on the wheel. The tertiary colors here are red-orange, yellow-orange, yellow-green, blue-green, blue-violet, and red-violet. If a primary is mixed with the secondary color opposite it on the color wheel, the result will be a more neutral tertiary such as brown or gray.*

## PRIMARY COLOR MIXES

The most vivid secondary colors are made by mixing primaries that are inclined toward the secondary you want to achieve. For example, cadmium red and cadmium yellow, which both have a yellow bias, produce a warm, vivid orange, whereas alizarin crimson (which has a blue bias) mixed with lemon yellow produces a paler, cooler orange.

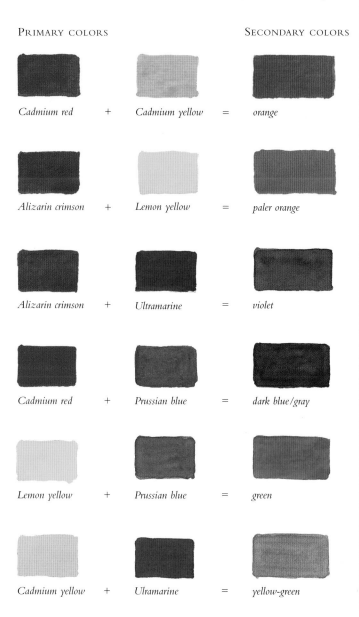

PRIMARY COLORS          SECONDARY COLORS

*Cadmium red*   +   *Cadmium yellow*   =   *orange*

*Alizarin crimson*   +   *Lemon yellow*   =   *paler orange*

*Alizarin crimson*   +   *Ultramarine*   =   *violet*

*Cadmium red*   +   *Prussian blue*   =   *dark blue/gray*

*Lemon yellow*   +   *Prussian blue*   =   *green*

*Cadmium yellow*   +   *Ulramarine*   =   *yellow-green*

## WARM AND COOL COLORS

Colors are often described in terms of "temperature," with blues and blue-greens described as cool and reds and oranges as warm. But it is not quite as simple as this, because each color, including the primaries, secondaries, and so-called neutral colors, has a warm and a cool version. The slightly blue alizarin crimson, for example, is cool in comparison with cadmium red, while ultramarine is warm in comparison with the slightly greenish Prussian blue. The concept of warm and cool colors is very important in painting, as it allows you to create a sense of depth. As objects become more distant, the colors become paler and cooler, so by using warmer colors for your fairy figures you will make them come forward in space.

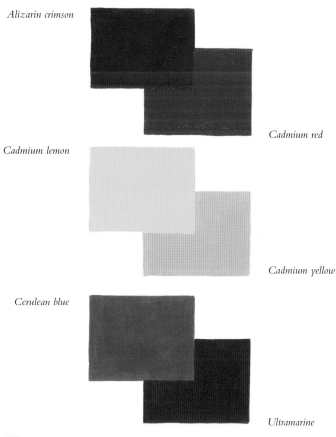

*Alizarin crimson*

*Cadmium red*

*Cadmium lemon*

*Cadmium yellow*

*Cerulean blue*

*Ultramarine*

### WARM AND COOL PRIMARY COLORS
*These swatches show two reds, two blues, and two yellows. In each case, one is warmer than the other. The crimson has a slight blue bias, and is cooler than the cadmium red. The lemon yellow is acid and greenish, cooler than the more orange cadmium yellow. Cerulean blue is cooler than the slightly purple ultramarine.*

## IDENTIFYING COLORS

Some colors are more difficult to mix than others, but it can be helpful to think your way through a checklist of points that will give you clues to the ingredients of your mix.

• What kind of color is it? Is it light, mid-toned, or dark?

• Which of your tube colors is nearest the main component?

• Does it have a distinct tinge of another color—which of your tube colors is nearest to that?

• Is it warm or cool?

• Is it intense or subdued?

These color swatches, right, show examples of how these principles can be applied.

|  WARM  |  COOL  |  DARK  |  LIGHT  |
| --- | --- | --- | --- |

*Cadmium red + Black + White* — *Phthalo green + Black + White* — *Dioxazine purple + Phthalo green* — *White + Lemon yellow + Black*

*Cadmium yellow + White + Dioxazine purple* — *Dioxazine purple + Raw umber + White* — *Ultramarine blue + Naphthol crimson* — *White + Dioxazine purple + Cadmium yellow*

## MODIFYING HUES

If a color is very strong, it can look artificial, and will therefore not be ideal for painting natural subjects (such as fairy habitats). This is quite often the case with acrylic colors. If you want to modify a hue quite subtly, try adding small touches of the more subdued earth colors such as muted browns and yellows. For example, mix burnt sienna into green, and yellow ocher in mauve.

*bright green* — *bright green + red violet* — *bright green + burnt sienna*

## ORDER OF MIXING

When mixing a pale color, start with the weakest ingredient, say, yellow or white. Then add the stronger colors such as red or blue in small quantities, building up gradually to the strength you require. If you start with a strong hue you will have to add much more of the mixer color, wasting a lot of paint.

## STANDARD PALETTE

This palette will allow for a very wide range of mixtures, and would be suitable for acrylic and pastel and colored pencil as well as watercolor, though for these you would need to buy two or three different shades of each color.

*Cadmium red, primary. Warm and brilliant.*

*Alizarin crimson, primary. Cool, mixes well with Ultramarine.*

*Cadmium yellow, primary. Warm and strong.*

*Lemon yellow, primary. Cool, with a slight green tinge.*

*Yellow ocher; can be mixed but usually classified as primary. Warm and slightly opaque.*

*Raw umber, tertiary. Excellent in mixtures and good for base skin tones.*

*Burnt umber, tertiary. Warm and strong.*

*Raw sienna, tertiary. Strong yellowish brown.*

*Olive green, secondary. Warm, with a yellow tinge.*

*Hooker's green, secondary. Dark and cool.*

*Prussian blue, primary. Strong, cool, with a slight greenish hue.*

*Ultramarine, primary. Warm and strong.*

*Imperial purple, secondary. More brilliant than mixtures of red and blue.*

*Lamp black; not essential, could substitute Payne's gray.*

*Chinese white, an alternative to white gouache for highlights.*

## FLORAL PALETTES

Nature is the best source when it comes to choosing flower colors, but if you can't get out into the countryside, or are painting in winter, there are many fine reference books that will help you to choose flowers and help you to work out a suitable palette. If you plan to paint a variety of flowers, check that they are in bloom at the same time of year, or you will compromise the seasonal aspect of your painting.

*Mixes of cadmium red, cadmium yellow, and lemon yellow are suitable for chrysanthemums and sunflowers. This sunflower center is sepia.*

*A wash of raw umber and olive green makes this creamy shade for daisies and narcissi. The flower center is pale orange and olive green.*

*Mixes of rose madder, magenta, and purple create pink shades for foxgloves, lilies, and orchids. The flower center is lemon yellow, and the highlights are white gouache.*

*Soft washes of cobalt blue and ultramarine are used for these forget-me-not petals, and darker mixes are used toward the center of the flower.*

*Washes of magenta and purple are used for the petals of red campion flowers, and deeper magenta is used toward the center. The pollen is cadmium yellow.*

*A combination of olive green and rose madder can be used for young flowers. Add some ultramarine to the rose madder for young bluebells.*

*A mix of ultramarine, purple, and lilac can be used for anemones, bluebells, and lavender.*

*Vibrant flowers such as geraniums and poppies are achieved with cadmium red and alizarin crimson. Payne's gray and purple madder are used for the center.*

*Buttercups and daffodils are achieved with cadmium yellow, lemon yellow, and a touch of orange. The pollen is lemon yellow.*

## SEASONAL PALETTES

Because fairies are so closely associated with nature and the seasons, it is important to choose a palette of colors that reflects this. Spring, for example, is typically bright and hopeful, requiring light or bright colors, while winter is darker and gloomier in mood. Have a look at the step-by-step demonstration paintings later in the book to see how strongly the choice of colors influences the look and feel of the painting.

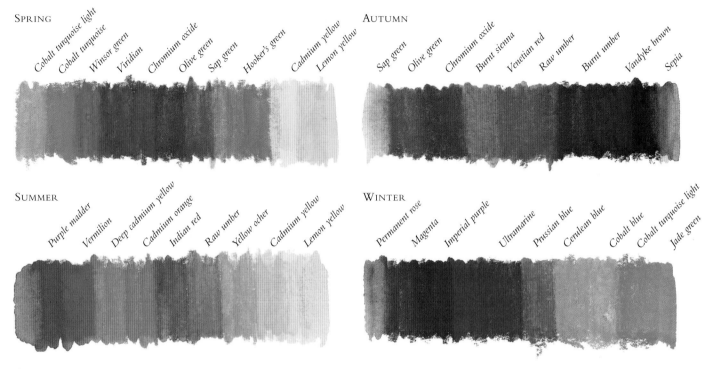

SPRING

*Cobalt turquoise light · Cobalt turquoise · Winsor green · Viridian · Chromium oxide · Olive green · Sap green · Hooker's green · Cadmium yellow · Lemon yellow*

AUTUMN

*Sap green · Olive green · Chromium oxide · Burnt sienna · Venetian red · Raw umber · Burnt umber · Vandyke brown · Sepia*

SUMMER

*Purple madder · Vermilion · Deep cadmium yellow · Cadmium orange · Indian red · Raw umber · Yellow ocher · Cadmium yellow · Lemon yellow*

WINTER

*Permanent rose · Magenta · Imperial purple · Ultramarine · Prussian blue · Cerulean blue · Cobalt blue · Cobalt turquoise light · Jade green*

## SKIN TONE PALETTES

Skin tones can be difficult to mix, as they vary so enormously. Here are three basic mixtures with various highlights and shadows. For other-worldly fairies, you may want to add a touch of blue or green to the basic mixture.

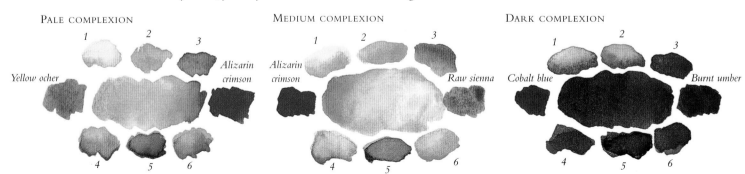

PALE COMPLEXION

*Yellow ocher* — *Alizarin crimson* — 1, 2, 3, 4, 5, 6

MEDIUM COMPLEXION

*Alizarin crimson* — *Raw sienna* — 1, 2, 3, 4, 5, 6

DARK COMPLEXION

*Cobalt blue* — *Burnt umber* — 1, 2, 3, 4, 5, 6

HIGHLIGHTS SHOW THE MAIN COLOR PLUS
*1. Lemon yellow 2. Cadmium yellow 3. Cadmium red*

SHADOWS SHOW THE MAIN COLOR PLUS
*4. Cobalt blue 5. Payne's gray 6. Viridian*

# COPYING IMAGES

Throughout this book there are images for you to trace or copy. Here are some tips to help you render these images effectively.

## TRACING

You can find good-quality tracing paper from most art or stationery stores. Using a small piece of masking tape, secure the tracing paper to the image you wish to copy, and draw over the image with an HB pencil. To check how much of the image has been traced, simply slide a plain piece of white paper between the tracing paper and the image, and you will instantly see how much of the image has been drawn. When you are happy with the drawing on your tracing paper, you can then transfer it to your chosen drawing surface using one of the two methods below.

### CREATING A MIRROR IMAGE

Simply turn over the tracing paper so that the pencil lines are facing the drawing surface, tape the sheet to the top of the paper, and, using a 6H pencil with a sharp point, draw very carefully over the lines. Lift the tracing paper occasionally to check how much of the image has transferred. When you are happy with the drawing, reinforce the lines of your image using an HB pencil.

### DUPLICATING THE IMAGE

On a thin sheet of paper such as copier paper, use a graphite stick or a 6B pencil to cover one side of the sheet with a thick layer of graphite. This can then be used in the same way as a carbon sheet: Place the graphite-covered paper, graphite-side down, on top of the drawing surface. Secure the tracing paper (onto which you have already traced your chosen image) face up, over both sheets. Draw over the image with a hard pencil, applying slight pressure, and checking progress by lifting the tracing paper and carbon paper occasionally.

## USING A GRID

If you prefer to copy an image rather than trace it, you can place a grid of squares over it to break it up into sections. You can then tackle these one at a time, and so simplify the copying process. This method is very useful for recreating images at different sizes. It is well worth making a grid like this to keep with your art materials, since it can be useful for copying all sorts of tricky images, even still life.

1. SETTING UP THE GRID
Draw a grid of squares onto an acetate sheet with a permanent black pen. Place it over the image you want to recreate.

2. COPYING THE IMAGE
Using a pencil, draw a grid with the same number of squares onto your drawing surface, and draw the image onto this, one square at a time.

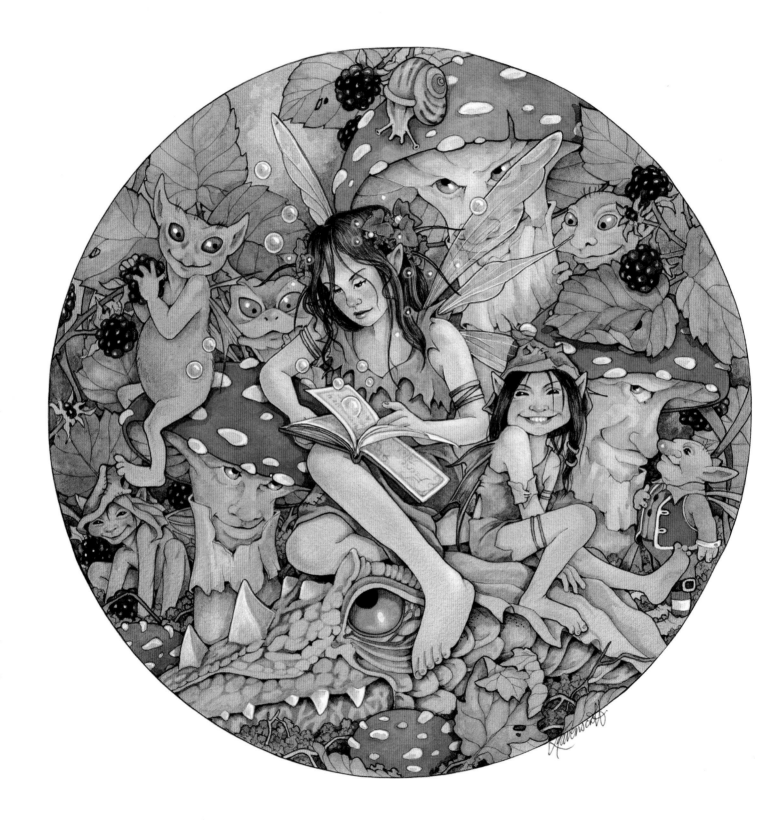

Chapter Two

# Basic Shapes and Forms

# FAIRY FACES

It is important to remember that, although fairies are fantasy beings, they are based on the human form, so you can find inspiration all around. These pages will help you to create a simple fairy face, and once you have experimented with the basic form you can try out different features and hairstyles. Use your imagination, as fairies don't have to look completely human, nor have a specific gender—some can appear androgynous.

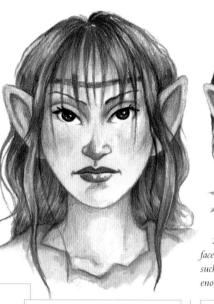

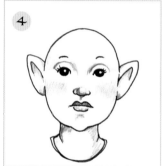

*Simplicity is the key to drawing fairy faces, and just a few exaggerated details such as pointed ears and chins are enough to give them a pixie quality.*

## CHILD FAIRY: FRONT VIEW

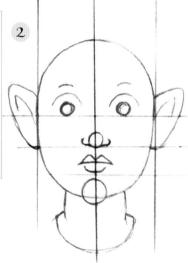

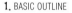

**1. BASIC OUTLINE**

The fairy child's face is the best place to start, as it is easier to draw than the adult's face. Draw a center and two side lines, and then draw two joined-up U shapes for the face. Make a small round circle in the middle for a nose and two small round shapes for eyes, placing these in the center of each of the two sides of the top half of the head. For the chin, draw a larger circle at the bottom, sitting just below the edge of the U shape.

**2. ADDING FEATURES**

Draw lips in the center between the chin and the nose. Put two small semicircles at the side of the nose for nostrils, two larger ones above the eyes for eyelids, and two more for eyebrows. Ears are large ovals, the bottom of which should be in line with or just below the tip of the nose.

**3. INKING THE DRAWING**

Draw around the face with a sepia pen except for the eyelids and tip of the nose, and then remove all unwanted pencil lines.

**4. ADDING SHADOW**

Using the 2B pencil, add some shading around the nose and above the eyes and chin.

**TEMPLATE FACE TO TRACE**

*Trace this basic face and then use your imagination to make it look completely different. You can make slight alterations as you work, such as making the chin a little shorter or the ears smaller, and adding different hairstyles.*

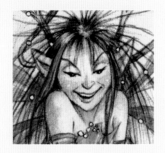

## YOU DON'T HAVE TO BE PERFECT AT PORTRAITURE

The great thing about fairy painting is that, because you are not making a portrait of a real person, it doesn't matter too much if you are not brilliant at drawing faces, providing you can capture some character. When making up fairy faces without using reference material such as photographs, start with an outline sketch and then decide what the character should be: kind, mischievous, cute, grumpy, aloof, or evil? Often the best way to proceed with a fairy painting, especially when you are starting out, is not to plan it in advance, but to just let it evolve naturally.

# ADULT FAIRY: FRONT VIEW

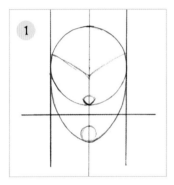

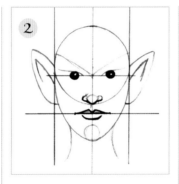

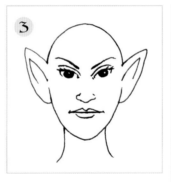

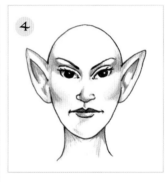

**1.** BASIC OUTLINE
Draw a circle with a line through the middle and two lines touching the outer edges. Extend it into an egg shape. Draw a small circle at the bottom of the first circle for the nose, and a large one at the bottom of the egg shape for the chin, with a horizontal line halfway between to mark the mouth. From the center of the first circle, draw two lines marking out a third for the eyebrows.

**2.** ADDING FEATURES
For the eyes, draw two small circles in the center of each half of the big circle. Draw oval shapes around them and define the eyebrows. Draw lips above and below the horizontal line, and make two small semicircles at each side of the nose for nostrils. Draw ovals for the ears, placing them level with the tip of the nose.

**3.** INKING THE DRAWING
Once you are happy with the face, draw it in with a pen and erase the pencil lines.

**4.** ADDING SHADOW
Using a 2B pencil, add in some shading, noting where cheekbones and eye sockets might be. The top lip is usually darker than the bottom, because it is in shadow.

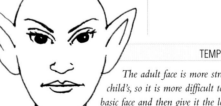

### TEMPLATE FACE TO TRACE

*The adult face is more structured than the child's, so it is more difficult to draw. Trace this basic face and then give it the look you want.*

# Child Fairy: Three-Quarter View

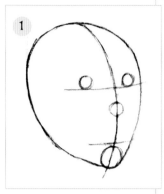

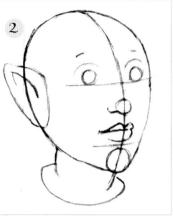

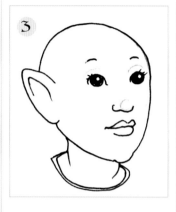

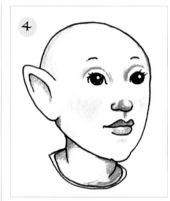

**1.** BASIC OUTLINE
Draw a teardrop shape at an angle, then add an almost parallel crescent shape to the side to form the center line. Place a small circle in the center for the nose, a larger one at the base for the chin, then add two small circles for the eyes.

**2.** ADDING FEATURES
Draw semicircles for eyelids, brows, and one nostril. Pay special attention to the mouth; it has one long and one short side as it is seen in perspective. Use a slightly rounded triangle shape for the ear.

**3.** INKING THE DRAWING
Draw in the details with a pen, except for the eyelids and the circle at the tip of the nose. Remove the unwanted pencil lines.

**4.** ADDING SHADOW
Add shading using a 2B pencil, replacing the eyelids and the round shape at the bottom of the nose.

## See Also:

SWIPE FILE: FAIRY FEATURES *pages 34–35*
SWIPE FILE: HAIR AND HEADDRESSES *pages 52–53*
SHADING *page 55*

### TEMPLATE FACE TO TRACE

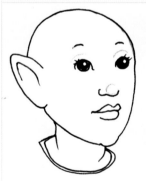

*Trace the basic face and use its proportions as the basis for your own version. Remember that the face is a three-quarter view, so the way you style the hair should reflect this.*

## FACIAL EXPRESSIONS

So much of a fairy's character resides in the face that it is important to think about how facial features can be arranged and manipulated to produce different expressions. Here are a few to get you started, but as you practice, you will find that the possibilities are endless.

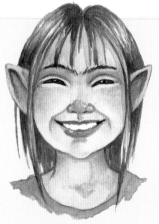

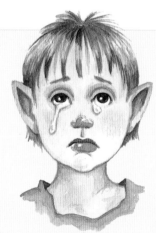

*Happy*

*Sad*

# ADULT FAIRY: THREE-QUARTER VIEW

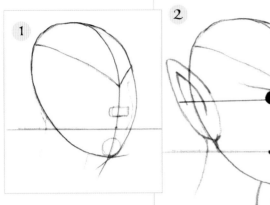

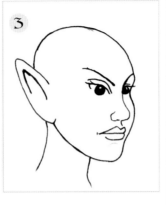

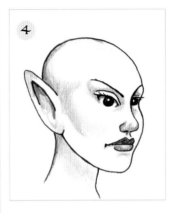

**1. BASIC OUTLINE**
Draw a large teardrop shape at a slight angle and add a crescent-shaped slice to the edge to give a center line through the face. Place a circle at the bottom for the chin, leave a space about the same size as this circle, and mark a rectangle for the nose. Draw a horizontal line for the mouth halfway between chin and nose, and eyebrows radiating from the center line.

**2. ADDING FEATURES**
Draw features in the same way as for the front view, and place the mouth as for the child fairy. The ear is more visible than in a front view, so be sure of its placement: the bottom should line up with the bottom of the nose; the top is level with the eye. The tip can protrude, as pointy ears are a feature of fairies.

**3. INKING THE DRAWING**
When you are happy with the general look of your face, use the pen to go around the edges, and then remove the pencil lines.

**4. ADDING SHADOW**
Adding shading to the face will give it some life and structure. Again, you can use this face as the basic form for more fairies.

*Confused*

*Disgusted*

*Angry*

*Sly smile*

TEMPLATE FACE TO TRACE

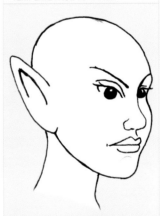

*If you're not particularly confident working with this perspective, tracing will help you to develop a feel for it.*

# SWIPE FILE:
# FAIRY FEATURES

YOU CAN HAVE fun with these pages, as they are designed to give you ideas for different facial features, giving an individual look to each of your fairies. All the eyes, noses, mouths, and ears are drawn to the same scale so that you can combine them in one image. You can copy them by hand, or you might try photocopying the pages and cutting out the individual features so that you can combine them in different ways. Alternatively you can trace them onto tracing paper, starting with the main lines and then adding shading. Begin with the eyes, as they will help you to build up the rest of the face, then trace on one of the noses between them, pick one of the mouths and add it to the sheet, and hey, presto! You have all the features. All you then need to do is draw a face shape around them and add some ears and hair of your choosing (see pages 52–53 for ideas on hairstyles). You can create many weird and wonderful faces from these pages, so practice copying them out freehand, as this will give you the confidence to try creating some of your own.

*You can trace this face and add your choice of features.*

*An adult female's nose is fine but soft and rounded.*

BEGINNERS start with this one

*A small nose for a child fairy*

*Flared nostrils look impish.*

*Male fairies' noses are broader than those of females.*

*A little touch of pink imparts warmth and youthfulness.*

*A nose ring for a woodland hippie*

*A long and thin nose suits an older fairy.*

*Colored lips are another way of making your fairies look otherworldly.*

*A displeased pout*

*A typically cheeky gesture*

*Thin, blue lips have a celestial look.*

*The mouth in speech, or about to eat*

*A perfect set of teeth for a beautiful fairy*

BEGINNERS start with this one

*The mouth in repose*

*An upturned nose suits a scamp.*

*A lopsided, impish grin suggests playfulness and nonconformity.*

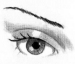

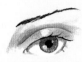

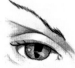

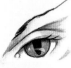

*Giving eyes a brilliant color such as this radiant blue hints at fairy magic.*

*Green eyes with shaped pupils have a feline quality.*

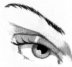

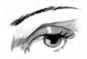

*A quizzical eyebrow suggests independence and willfulness.*

*Narrow black eyes are definitely not human.*

BEGINNERS start with these

*Round and black, these eyes are soft and unthreatening.*

*Narrowed eyes look mischievous.*

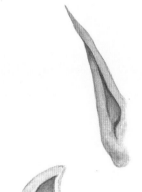

*You can trace this face and add your choice of features.*

BEGINNERS start with this one

*This basic shape is all you need for a fairylike appearance.*

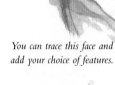

*Long, thin ears suit the most ethereal fairies.*

*Every detail of this ear is pointed.*

*Younger ears are shorter and more fleshy.*

*Piercings give a tribal look.*

# FAIRY FIGURES

These pages show some ideas for drawing simple fairy forms in a series of simple steps. By building them up in blocks you should be able to create attractive adult or child fairy figures, and with a little practice you can learn to change the basic shapes. Always bear in mind that fairies are fantasy creatures and don't have to look too human, so you can play around with proportions to achieve your own interpretation of the drawings shown here. But begin by following some of the instructions and ideas, as they are intended as a useful starting point.

## Child Fairy: FRONT VIEW

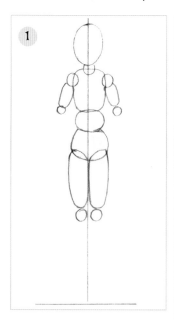

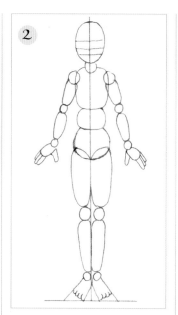

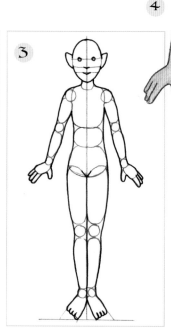

**1.** FIRST STEPS
Draw an oval shape for the head, a small circle for the neck, a slightly larger oval for the chest, then another one for the stomach and hips. Draw small circles for the shoulder joints, and add the upper arms and elbows. The thighs are long ovals and the knees are circles.

**2.** BUILDING UP THE BODY
Mark out the lines for the facial features (see pages 30–33). Draw ovals for the lower arms, small circles for wrists, and rounded oval shapes for hands, adding thumbs and fingers. The lower legs are tapering ovals. Add small circles for the ankle joints, and from these, add the feet by drawing two lines at 45-degree angles on either side and joining them at the bottom.

**3.** OUTLINING THE BODY
Sketch in the facial features lightly and then outline the whole figure. Add a small curved shape to represent the pubic area. You can either draw around the image with pen before removing the pencil lines, or you can place a sheet of tracing paper over the image and redraw it.

**4.** CLOTHING THE FIGURE
Now you can add details such as hair, clothing, and wings (see pages 41–43 for wings and wing positions), and color and shading.

# ADULT FAIRY: FRONT VIEW

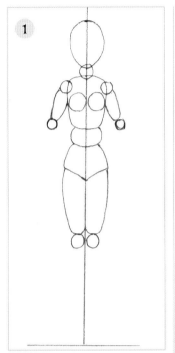

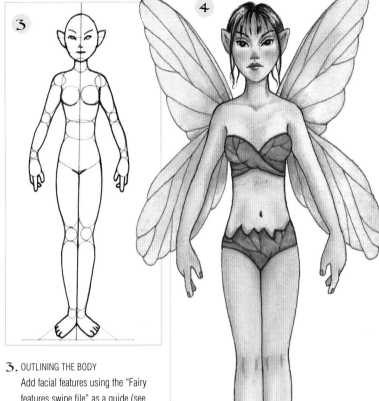

## 1. FIRST SHAPES

Draw an oval for the head, a small circle for the neck, and a rectangular shape with rounded edges for the chest area. The stomach is a small oval shape slimmer than the chest, and the hips start the same width as the stomach and expand to the same width as the chest. Add circles to the middle of the chest if you are drawing a female. Draw small circles for the shoulders, then slim ovals for the upper arms and small circles for the elbows. Add elongated ovals for the thighs, and two circles beneath for the knees.

## 2. BUILDING UP

Divide the face into segments as shown in "Fairy faces" (pages 30–33), and add slim ovals at the elbows for the lower arms, then small circles for wrists, and more rounded ovals for hands. The fingers are simple sausage shapes. The lower legs are elongated ovals tapering in slightly toward the ankles. Add circles for the ankles, then draw two parallel lines on either side of each ankle joint. When you are happy with the foot length, draw a line across and put in small toe shapes.

## 3. OUTLINING THE BODY

Add facial features using the "Fairy features swipe file" as a guide (see pages 34–35), then draw around the whole figure with smooth, flowing lines, ignoring the dips between the shapes, and tapering in and out slightly around the joints. Draw a line through the center of the legs to the bottom of the hip section and add a small curved line where the pubic area would be. For a female fairy, draw in the underside of the bust.

## 4. COMPLETING THE FAIRY

Finally, finish your adult fairy in the same way as for the child version, adding hair, clothing, and other accessories. As for the child fairy, you can either draw around the image with a pen, adding details as you go, or you can trace the image and redraw it.

# CHILD FAIRY: THREE-QUARTER VIEW

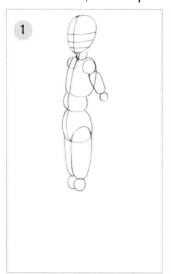

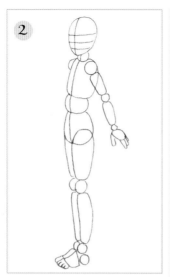

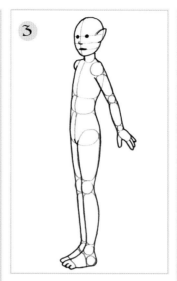

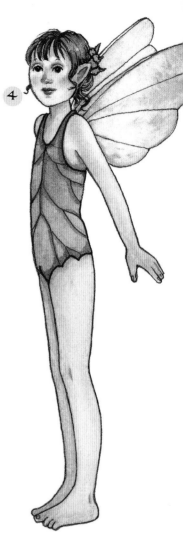

## 1. PLACING THE BODY SHAPES

Start with a teardrop shape for the head as shown for the child three-quarter view face in the "Fairy faces" section (see page 32), putting in lines for the features. Add a circle for the neck and a slightly curved barrel shape for the chest area, then add a small oval shape for the stomach and a larger off-center egg shape for the hips, bearing in mind the basic proportions shown for the front view. To find the center of your figure, draw a long curve about a quarter of the way in from the front of each shape. Add two small circles for the shoulders and draw in the top part of the near arm and elbow, using the same proportions as in the front view. Add the thighs and knees, noting that only about half of the farthest leg can be seen.

## 2. THE LOWER LIMBS

Draw a slim oval for the bottom half of the arm, tapering slightly to a small circle for the wrist. Draw a larger oval for the hand, adding thumb and fingers. The lower leg tapers toward the ankle; the curve is more pronounced at the back of the leg, and the shin is relatively straight. Draw a circle for the near ankle, a circle for the heel, a wedge shape for the foot, with small shapes for the toes. Then draw in the other leg and foot following the lines of the nearer one.

## 3. OUTLINING THE IMAGE

Draw around the entire image, adding the ear and facial features. When drawing the area around the inside of the armpit, make sure that the lines don't join with the shoulder at the top.

## 4. COMPLETING THE FAIRY

Complete the fairy by adding hair, clothing, and wings, following either of the procedures suggested for the front view (see page 36).

# ADULT FAIRY: THREE-QUARTER VIEW

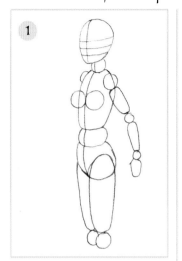

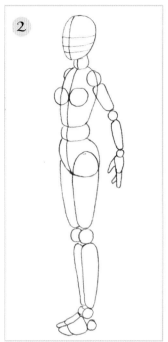

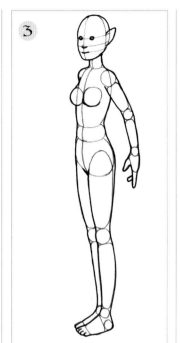

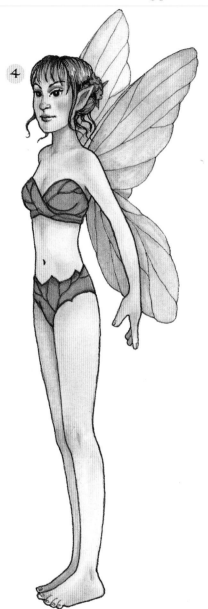

1. BASIC SHAPES

Start with the head, referring to the three-quarter-view adult fairy in the "Fairy faces" section (page 33). Draw a basic body shape as shown for the child fairy on page 38, then mark the curving center line of the figure about a quarter of the way in from the left-hand side. If your fairy is female, add two round shapes in the center of the chest area. Add small circles for the shoulder joints, noting that only the top of the far shoulder will be seen when the image is completed. Add a slim sausage shape to the near shoulder, tilting it outward slightly, then add the elbow joint and another sausage shape, slightly tapered near the bottom. Add a small circle for the wrist and a slightly wider oval for the hand. Starting with the nearer leg, add the thigh shapes, the second of which is only half visible, and then draw the circle and half circle for the knees.

2. HANDS AND FEET

Add the fingers, one pointing directly downward, a small section of finger showing from behind this one, and the thumb slightly curved. Add the lower legs, tapering slightly toward the bottom, then put in a small circle for the ankle and another one just below for the heel, and form the feet with a small wedge shape. Draw in the far leg using the near leg as a guide.

3. OUTLINING THE FIGURE

Add the facial features and draw around the outside of the figure. When drawing inside the upper arm, make the line slightly shorter. Draw the front of the nearer leg to separate them, but take the line up only as far as the hip section, and mark in a small v shape to represent the pubic area. If your fairy is female, draw around the underside of the circle nearest to the arm and just a small section underneath the far breast, tapering the top into the chest.

4. COMPLETING THE FAIRY

Complete the fairy by adding hair, clothing, and wings, following either of the procedures suggested for the front view.

## SEE ALSO:

FAIRY FACES *pages 30–33*
SWIPE FILE: FAIRY FEATURES *pages 34–35*
FAIRY WINGS *and* SWIPE FILE *pages 41–43*
SWIPE FILE: FAIRY FASHIONS *pages 56–59*

# PROPORTIONS

In figure drawing, the size of the head gives you a guide to the full height of the figure. A standard adult human body is approximately 7½ heads high. But this can be varied for effect when drawing fantastical beings such as fairies—a larger head will make a fairy look cuter, whereas a smaller head on a body with long, tapered limbs and digits can help to create a more ethereal appearance.

USING A MANNEQUIN
*To help you draw fairy figures, consider buying an artist's wooden mannequin. These are widely available in various sizes in most good art and craft shops, and like the drawings shown below, simplify the figure by dividing it into basic shapes. The limbs and other body parts are movable, which make them especially useful when you want to show your fairies in action.*

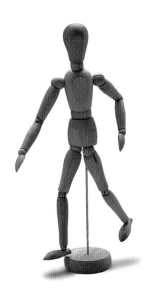

## ADULT FAIRY

The full body of this adult fairy is about 6½ heads high. Being female, her waist is tapered and she has breasts. A male adult would have similar proportions, but the shape of his body would be less rounded and less tapered.

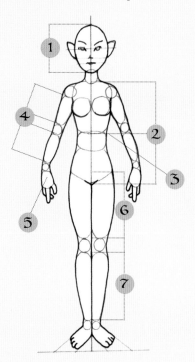

HELPFUL GUIDELINES

1. The size of the head is used as a guide for the height of the entire figure.
2. The stomach and hips are about the same length as the chest.
3. If the arms were flat to the sides of the body, the upper arms and elbows would reach the bottom of the chest section.
4. The lower arms are about the same length as the upper arms.
5. Hands are about half the length of the upper arms.
6. The thighs and knees are about three-quarters of the length of the torso.
7. The lower legs are about the same length as the thighs.

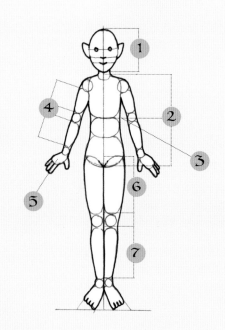

## CHILD FAIRY

The proportions for a child differ in that the younger the child, the larger the head in relation to the rest of the body. A child's body shape is slightly rounder than that of an adult, and, for females, the waist is less tapered.

# Fairy Wings

Fairies are small, very delicate creatures and most of them are blessed with wings, some bold and colorful as butterflies, some transparent like dragonflies, and others with angel-like feathers. The choice is vast and varied, but whatever type of wings your fairy has, it is important to make sure that they are placed in the right position. Ideally they should be seen as growing from a place between the shoulder blade and the arm, as this part of the shoulder is very strong and flexible and moves whenever the arms are raised. This placing makes the idea of flight more credible and gives the illusion that the wings will have enough power to lift your fairy off the ground.

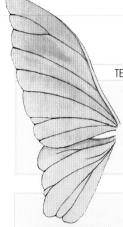

### TEMPLATE WING TO TRACE

*Trace the template wing at the side of this image; place it over any of the fairy drawings in this section and practice fitting the wings into place.*

## Shapes and Sizes

*Whatever their size, wings don't vary in shape all that much. Most wings are wider at the top, tapering inward to the point where they meet the body, which makes it easier to visualize where they should be placed. Even if your fairy is as light as a feather and doesn't need huge wings in order to fly, you can achieve the right look by putting them in the correct place.*

# Placing the Wings

**1**

*The dotted area shows where the other wing will be placed.*

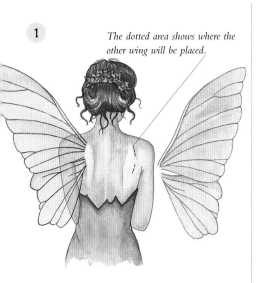

**2**

*The dotted lines indicate the way the wing fits at the shoulder on the fairy's back.*

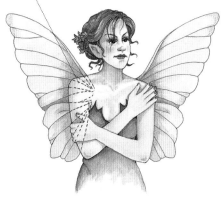

*The wing drawn in red ink is on the far shoulder.*

*The wing drawn in black ink is on the near shoulder.*

**3**

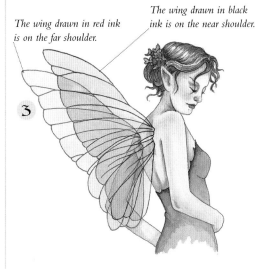

**1.** BACK VIEW
In this view you can see the shoulder and where the wing has been attached.

**2.** FRONT VIEW
The front view shows both wings fixed into position. As you can see, most of the upper half of the wing is visible, but the tapered end is hidden behind the figure.

**3.** THREE-QUARTER VIEW
This view is slightly more complicated, but because both shoulders are visible, fitting the wings is not a problem.

# SWIPE FILE:
# FAIRY WINGS

YOU CAN LET your imagination run wild when designing fairy wings, and there is almost unlimited inspiration to draw on—the wings of any flying creature can be adapted for the use of fairies, and you can also base them on leaf or flower forms or copy a fabric pattern into a wing shape.

Birds and butterflies don't stay still long enough for you to make a study of their wings, but natural-history books will provide a wealth of ideas. You can adapt some of the shapes and wing patterns to suit your own needs, as colors and designs can be applied to any type of wing shape, or you can choose to give them a transparent gossamer look, with pale washes of color or iridescent mediums. There are now many metallic pastels, inks, and paints available in art and craft stores, so don't be afraid to experiment.

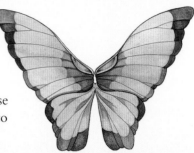

*Following the shape of butterfly wings, you can then color them as you wish to suit your fairy.*

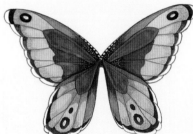

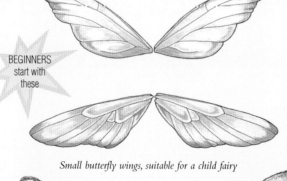

BEGINNERS start with these

*Small butterfly wings, suitable for a child fairy*

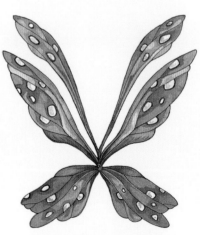

*Pink and delicate, a variation on butterfly wings*

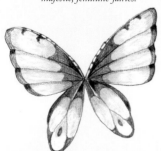

*Butterfly wings are full, rounded, and usually have lustrous colors. They suit majestic, feminine fairies.*

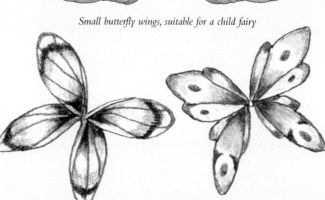

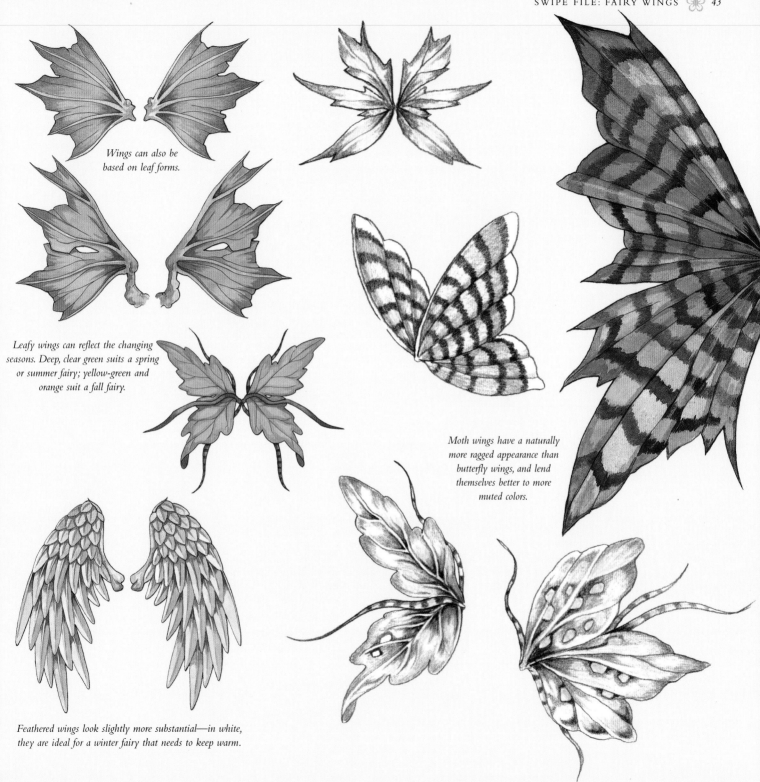

*Wings can also be
based on leaf forms.*

*Leafy wings can reflect the changing
seasons. Deep, clear green suits a spring
or summer fairy; yellow-green and
orange suit a fall fairy.*

*Moth wings have a naturally
more ragged appearance than
butterfly wings, and lend
themselves better to more
muted colors.*

*Feathered wings look slightly more substantial—in white,
they are ideal for a winter fairy that needs to keep warm.*

# Hands and Feet

Hands and feet are notoriously hard to draw, but it is important to master them because hands play an important part when any activity is involved, and fairies are often seen without shoes or stockings, their barefoot simplicity being part of their charm. As with any part of the body, there are ways of simplifying by breaking them up into basic shapes, which will help you to make these difficult extremities look realistic and convincing. And, of course, you can always practice by drawing your own hands and feet, even if they are not entirely fairylike.

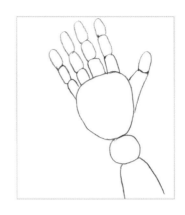

BASIC SHAPES

Draw an oval slightly flattened at the top, and add a circle for the wrist and two lines on either side to represent the arm. Starting at the top right-hand side, draw four small sausage shapes of similar width but slightly varying lengths; the first finger is shorter than the middle two, and the little finger is smaller still. Divide them equally along the top part of the oval; add a total of three small sausages to each finger for the knuckles and joints. The thumb has only one joint and is attached to the side of the oval.

## Basic Hand: Back View

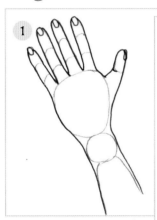

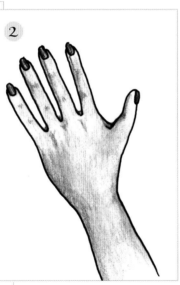

1. BACK OF THE HAND

Once you are happy with the shapes of the hand and fingers, you can draw around the outline to see the hand shape more clearly. For the back of the hand, all you need to do is add fingernails and suggest the knuckles and upper finger joints, using the original sausage shapes as a guide.

2. ADDING COLOR AND SHADING

Now you can outline the image in ink or trace it onto tracing paper, adding the nails and some shading to give form to the hand.

## Basic Hand: Palm View

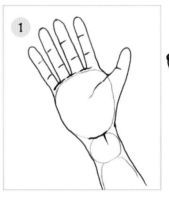

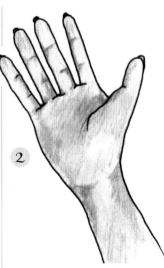

1. PALM OF THE HAND

To draw the palm, you can use the same basic shapes as for the back of the hand. Leave out the fingernails, draw a curve around from the thumb into the hand, mark out the joints of the fingers with light lines, and then draw small curved lines at the base between each finger, adding a slight upward curve where the hand and the wrist join. Complete the hand as before, erasing the pencil lines when you have made the ink outline.

2. ADDING COLOR AND SHADING

Complete the hand as before, erasing the pencil lines when you have made the ink outline, and adding shading.

# BASIC FOOT: SIDE VIEW

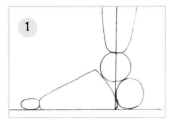

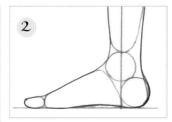

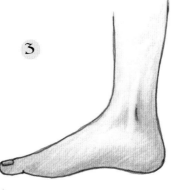

**1. BASIC SHAPES**
Draw a central line with a horizontal one at the bottom. Draw a small circle on the horizontal line with the left-hand edge flush against the central line, then add another circle of similar size above this, placed on the central line. Draw two tapering lines to represent the bottom half of the leg, and then draw a slightly rounded triangular shape along the horizontal line and just touching the small circles. Add a small oval for the toes, again on the horizontal line.

**2. OUTLINING THE SHAPES**
Draw around the entire outline to form the basic foot shape. Add a slight arch to represent the instep.

**3. COMPLETING THE FOOT**
Finish the drawing in the usual way, noting that just one toenail is visible. This simple side view requires very little detail.

## PERSONAL INTERPRETATIONS

Hands and feet have to look as though they are capable of serving their functions, but they don't have to be humanlike in every detail, and you can play around with different styles, as with wings, hairstyles, and clothing. You might go for a long, thin look and elongate them, or give them only four digits, which can help to make them look more mystical and otherworldly. You could also try making the palms of the hands and the main part of the foot longer or making the fingers and toes unusually slim to give a more ethereal look to fairies who don't have daily chores to perform.

# BASIC FOOT: FRONT VIEW

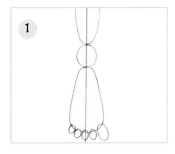

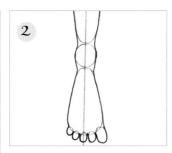

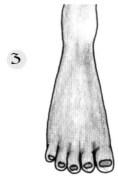

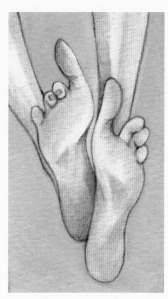

**1. BASIC SHAPES**
Draw a central line, then add a small circle with the line running through the center, and add two parallel lines above this, tapering down to the circle. Beneath the circle, draw a long rounded teardrop shape followed by five ovals to represent the toes, starting with the largest and gradually reducing the size.

**2. OUTLINING THE SHAPES**
Draw around the outline of the shape, ignoring any of the lines inside the shapes, and smoothing the contours where the shapes meet.

**3. COMPLETING THE FOOT**
Add the toenails, which are small, thin ovals, as they are foreshortened from this angle. Shade lightly below the ankle and on the sides of the foot and slightly more heavily between the toes.

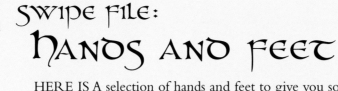

# SWIPE FILE:
# HANDS AND FEET

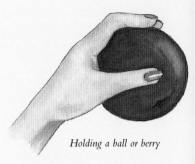

*Holding a ball or berry*

HERE IS A selection of hands and feet to give you some ideas. Trace them if you like, but it will be better practice to draw them freehand, and practice is vitally important for these tricky subjects. Some of the drawings may look complicated, but if you break them down into simple shapes as shown in the previous section, you should be able to recreate some of them without too much difficulty.

People often make the mistake of putting in too much detail, with undue attention to knuckles and skin folds, but if you study these drawings you will see that detail has been kept to a minimum and yet they still look quite lifelike. Decide how much detail to include only after you are happy with the basic shapes; you may find you need very little. If you do have a lot of trouble, bear in mind that you can always cover the extremities with gloves or shoes and stockings.

**BEGINNERS** start with these

*Long cuffs and fingerless gloves can be used to simplify the hand shape.*

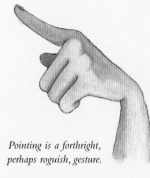

*Pointing is a forthright, perhaps roguish, gesture.*

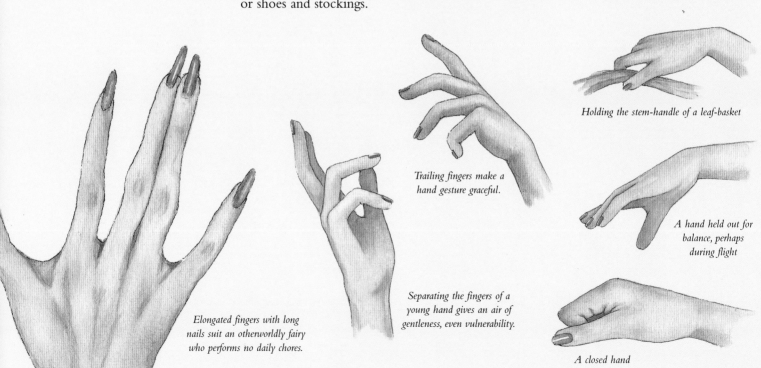

*Holding the stem-handle of a leaf-basket*

*Trailing fingers make a hand gesture graceful.*

*A hand held out for balance, perhaps during flight*

*Elongated fingers with long nails suit an otherworldly fairy who performs no daily chores.*

*Separating the fingers of a young hand gives an air of gentleness, even vulnerability.*

*A closed hand*

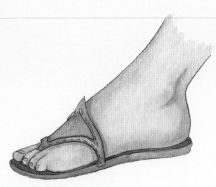

*Footwear closely follows the contours of the foot.*

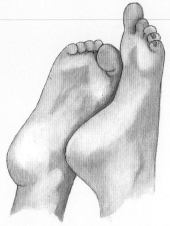

*The owner of these feet could be lying on her front or diving into a pool.*

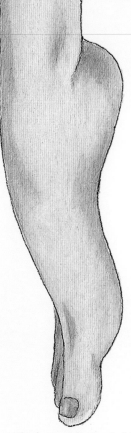

*This foot is not bearing the fairy's weight—perhaps it is airborne.*

*From the front, looking down*

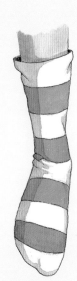

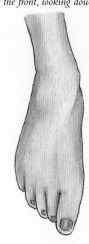

BEGINNERS start with this one

*Stripy socks are both fun, and a useful way of covering the details of the foot.*

*This fairy is perhaps standing straight legged, knees facing slightly inward, in an impishly confrontational stance.*

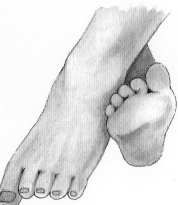

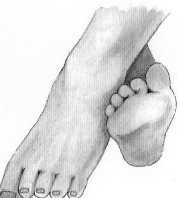

*The dangling feet of a carefree, seated fairy*

*Giving a foot just four toes is a neat way of setting a fairy apart from the human realm.*

# CLASSIC FAIRY POSES

Fairies are most often seen either flying, sitting among flowers and leaves, or perching on toadstools, and are generally portrayed as beautiful sylphlike creatures or cute little children. These pages show a small selection of typical fairy poses, some of which are more difficult to perfect than others: the fairy with her legs crossed, for example, is quite hard to draw. The artists' wooden mannequin mentioned on page 40 is very helpful in this context, as its movable parts allow it to be arranged in a wide variety of poses, and it also shows you how the body can be broken down into sections, as in the drawings here. It can also be of help when you use photographic reference or draw from life, as you can sketch out the basic shapes first and gradually build up the figure around them.

# KNEELING FIGURE

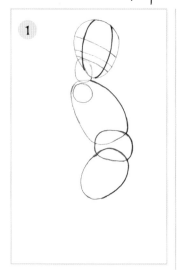

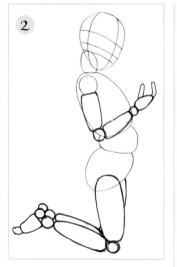

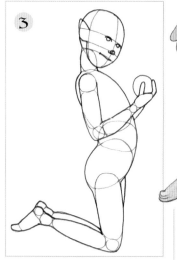

*Delicate wings give a youthful impression.*

*Shading makes the berry look more succulent.*

**1.** FACE AND BODY
This is a side view, with the face turned toward us to show the features. Draw the head as in the three-quarter view in the "Fairy faces" section (see pages 30–33), and then add the body segments, which are curved forward to form a banana shape.

**2.** ARMS, LEGS, AND EXTREMITIES
Add arms and legs, using the elbow and knee joints as pivots to bend the limbs into position. Draw a small oval for the hand and add the thumb and forefinger (the other digits are not visible). The feet are bent back to give a slight curve from ankle to toes. Start with the main foot and then draw in the other one behind it, following the same line.

**3.** OUTLINING THE FIGURE
Add the facial features to the figure using the guidelines in the "Fairy faces" section, then draw around the outline as before, placing a circle in the hand for the red berry the fairy is holding.

**4.** COMPLETING THE FAIRY
Complete the fairy with hair, clothing, and wings of your choice. Here the berry has been painted in a juicy red, and a lightly suggested green leaf has been added beneath the knees for contrast.

# FLYING FIGURE

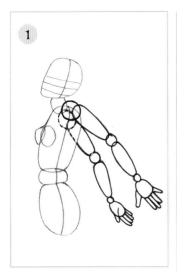

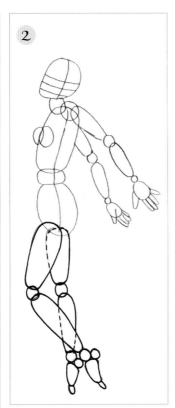

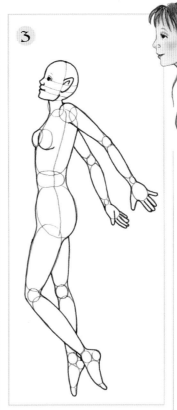

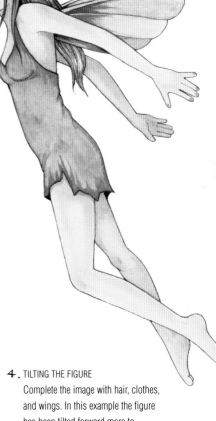

**1.** HEAD, BODY, AND ARMS

Draw the head in a teardrop shape, dividing it into segments for the features, then add a circle for the neck and large oval shapes for the chest, stomach, and hips. Draw a line through the shapes just right of center to show the side of the body, and if you are drawing a female, add circles for the breasts, just off to the right of the chest. Draw in circles at the shoulder central to the side of the body line and then make dotted lines for the far shoulder—they will not be seen when the image is complete, but they make it easier to work out the size and position of the left arm. Draw in the rest of the arms as shown, and draw two small ovals for the hands and add digits, noting that the left hand is facing palm upward as it would be when flying.

**2.** LEGS AND FEET

Add the legs, one straight and the other in a flexed position to help give the feeling of movement. The dotted lines show the positioning of the far leg, and the areas that won't be seen in the final image. The feet are in a pointed position to give the impression of flight.

**3.** OUTLINING THE FIGURE

Complete the line drawing by adding the facial features, and then draw around the outline of the entire figure.

**4.** TILTING THE FIGURE

Complete the image with hair, clothes, and wings. In this example the figure has been tilted forward more to strengthen the impression of flight, which is further reinforced by the secondary motion of the fairy's hair.

# CROSSED LEGS

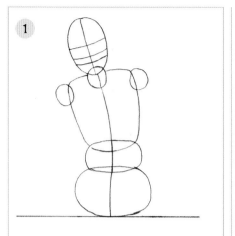

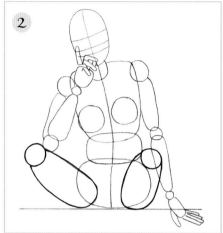

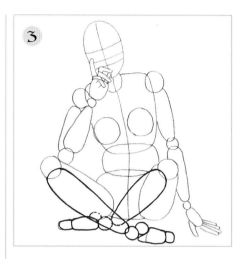

**1. HEAD AND BODY**
This pose is a little more complicated than the others. Draw the body first, noting the way the figure is tilted, and mark a horizontal line beneath the hips to indicate the place where the buttocks rest on the floor.

**2. ARMS AND LEGS**
Now add the arms, one reaching down to the floor and the other bent, with the hand under the chin. Place the legs by drawing two ovals for the thighs and two circles for the kneecaps. One of the leg shapes appears to be longer than the other, although one knee is only slightly higher than the other.

**3. ANKLES AND FEET**
Now draw the calves of the legs, making one slightly smaller than the other to give the impression that one leg is in front of the other one. The dotted lines show how the ankle and foot would be positioned behind the front leg.

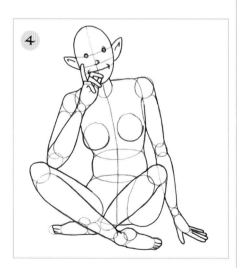

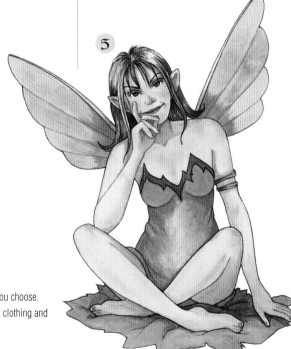

**4. OUTLINING THE FIGURE**
The facial features can now be added and the outline of the figure drawn. Erase the pencil lines once the outline has been inked.

**5. COMPLETING THE FAIRY**
Complete the fairy in whatever way you choose. Here she is shown with lilac hair and clothing and sits on a leaf.

# TIP-TOE FAIRY

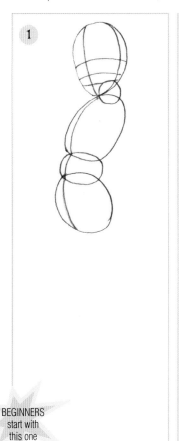

**1**

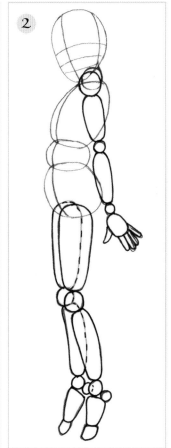

**2**

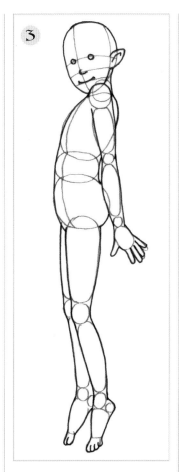

**3**

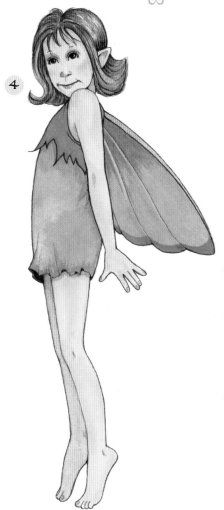

**4**

BEGINNERS
start with
this one

**1. HEAD AND BODY**
Draw the head as a three-quarter view and the body as a side view so that the right arm is not visible.

**2. ARMS AND LEGS**
Add the arm and legs, noting that the shoulder is up higher than it would be in a relaxed pose. This gives the illusion that the figure is hunching up one shoulder, which can give quite a cute appearance. The dotted lines show how the far leg would be positioned, and which parts of it will be hidden.

**3. FEATURES AND OUTLINE**
Fill in the facial features as for a three-quarter view, and then continue to draw around the entire outline of the image until the figure is complete. The head is slightly angled, so the ear is placed higher up the head shape.

**4. COMPLETING THE FAIRY**
With the hair, clothing, and wings added, the final look is of a rather cute little fairy, with the tiptoe stance giving her a dancerlike look of lightness and agility.

## SEE ALSO:

FAIRY FACES *pages 30–33*
FAIRY FIGURES *pages 36–39*
FAIRY WINGS AND SWIPE FILE *pages 41–43*
SWIPE FILE: FAIRY FASHIONS *pages 56–59*

# Swipe File:
# Hair and Headdresses

FAIRIES ARE RENOWNED for their long flowing hair and their ability to utilize plants and leaves to create wonderful wreaths and hair decorations, although they sometimes prefer a wild and carefree look. You can be just as creative yourself when designing hair for your fairy, and it's very rewarding, as a style can completely change the look and character of your fairy. You can also use hair or head decoration to create a theme for your painting as well as to dictate what your fairy represents; for example, blue or white hair might be used for a winter fairy, or green hair for spring.

Use your imagination and remember to look around you when you are out in the countryside—try to imagine what small flowers your fairies might use to make wreaths; perhaps they would choose grasses, leaves, or even empty nut shells. It's fun to collect leaves and make little hats by sewing them with natural-colored thread. Ivy leaves are excellent for this, as they are quite tough. The great thing is that it gives you a three-dimensional image so that you can visualize more easily what the hat or headdress would look like in use.

*A wreath of berries, a very traditional style of headdress, can be worn with long or short hairstyles.*

*A much more Celtic tribal look can be achieved by using twigs and beads; feathers can also be added.*

*This style, with twigs and natural grass ties, is both wild and ceremonial.*

*Hair tied back neatly with a corsage made from berries. The simple band on her forehead adds sophistication.*

*Easy-to-manage short cropped hair is suitable for fairies of either sex.*

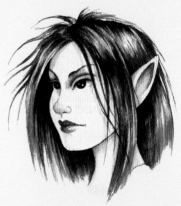

*This style, like the twig tiara, suggests the fairy's Celtic origins. Highlights are reserved to suggest the silky, shiny surface.*

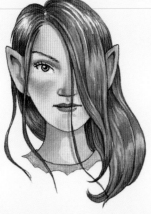

Beautiful flowing auburn hair the color of
the leaves in fall needs no other adornment.

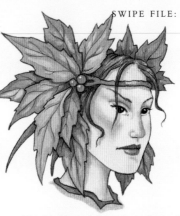

This headdress of elegant leaves frames the
face to give an ethereal, otherworldly look.

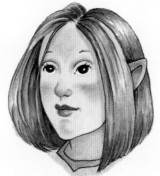

A simple, straight hairstyle suitable
for most fairies, and easy for them
to manage out in the woods

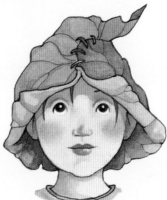

Quite sculpted and
funky, following
current fashions

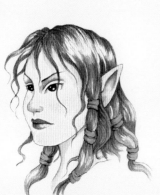

An up-to-date spiky style for a
mischievous little fellow

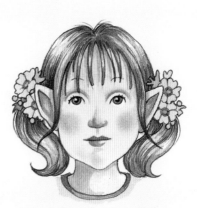

An ivy leaf has been formed
into an attractive rain hat.

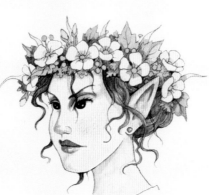

A floral wreath is an ideal accessory for a
flower fairy. A few separate tendrils can
often look better than a bushy mass of hair.

For a messy style like this, don't define too much
outline so that you can add wisps and layer
without them looking like an afterthought.

Cute little pigtails tied up with forget-
me-not flowers give a very sweet look.

# FORESHORTENING
## FLYING FAIRY

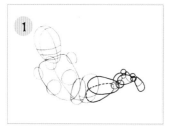

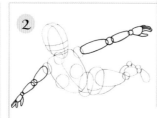

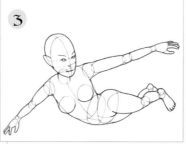

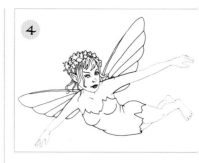

**1.** HEAD, BODY, AND LEGS

Draw the basic head shape as a three-quarter view. The chest is about the normal size, sweeping off to the right, and the ovals for the stomach and hips are the usual basic shapes although they are slightly shorter and overlap more to emphasize the bend of the body as it recedes backward. In this example, the legs and feet have been inked in to show that because they are farther away they appear to be considerably shorter than their actual length, with the calves very short indeed. The dotted lines show how the far leg would be positioned even though not all of it will be seen.

**2.** DIFFERENT LENGTHS

When adding the arms, note that the one on the right of the picture is much longer because it is coming forward while the other is receding. The basic shapes of the receding arm overlap more and you will find it easier to draw the full-length arm first and then shorten each of the oval shapes for the other one.

**3.** OUTLINING THE FIGURE

Roughly add in the features as for a three-quarter view face (see page 33), then draw around the whole of the outline, making sure that you only show the parts of the leg that would be visible to the eye.

**4.** ADDING THE WINGS

Add more definition to the face and hair and draw in the wings, again making them slightly different in size to indicate that the farther-off wing is more distant in space. Both wings reach the fairy's elbows, so the near wing is larger than the far wing.

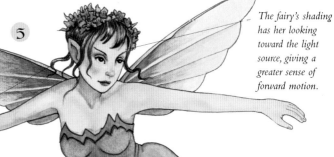

*Secondary motion in the hair enforces the impression that the fairy is airborne.*

*The fairy's shading has her looking toward the light source, giving a greater sense of forward motion.*

**5.** COMPLETING THE FAIRY

With a little shading added and the image colored in, it is much easier to see the effects of the foreshortening, which make it appear as though the fairy is flying toward us.

Foreshortening can be difficult, but it is very important if you want to create some realism and give a sense of dimension to your work. Foreshortening is a perspective effect that causes objects in the distance to appear smaller than they actually are, while those closest to us look larger. If a reclining figure—or a flying fairy—is seen from the head end, the forms will progressively shorten toward the legs and feet, and the feet themselves will be tiny in relation to the head, so we have to abandon the usual rules of human proportions and trust the laws of perspective.

## SEE ALSO:

FAIRY FACES *pages 30–33*
FAIRY FIGURES *pages 36–39*

# SHADING

In order for a painting to come to life, it is important to give it some depth, and this is done by shading, which simply means graduating the tones of colors from light to dark. To take a simple example, a spherical object will be pale in tone where the light strikes it, becoming progressively darker as it turns away from the light. So when you are creating something from your imagination, decide where your light source will be—picture it in your mind or draw it as a small circle lightly in pencil. If the light source is on the left, the parts of the image on that side will be brighter and the right-hand side will be more shaded, while any areas underneath legs, leaves, and so on will be darker still.

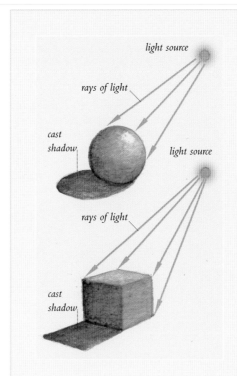

light source

rays of light

cast shadow

light source

rays of light

cast shadow

## LEARNING ABOUT TONES

To learn how light affects objects, you could use a small desk lamp to light up a still life object in different ways. Look at the shadows and highlights as they appear, and sketch them with a soft pencil, accentuating the light and dark areas. If the object is rounded, the gradations between the tones will be subtle, while on a hard-edged object such as a box, the divisions between tones will be very distinct.

PAINTING WITH NO SHADING
This shows how flat the image looks without any shading.

CENTRAL LIGHT SOURCE
Here the light source is centrally between the two fairy figures, illuminating the wings of the left-hand fairy and throwing those of the right-hand one into shadow.

# SWIPE FILE:
# FAIRY FASHIONS

FAIRIES CAN WEAR more or less anything, from dresses made of petals and flowers to wonderful exuberant flowing gowns made with silk spun by silkworms. They can also wear scaled-down versions of human attire, especially clothes of the Victorian era and earlier, so books on the history of fashion provide a marvellous source.

Another nice idea is to think of fairies as wearing clothes and other adornments that they have made themselves from natural materials such as plant or tree fibers and flowers, perhaps with the addition of a few abandoned and recycled items from the human world—for example, small buttons, safety pins, and even shiny, colorful candy wrappers.

Fashion designing for fairies is great fun to do, as the options are endless, so whenever you go out walking, look out for items that might be used by the fairies. Study flower shapes and colors and try to visualize how they might be adapted to make some form of clothing or footwear. Hopefully the images on these pages, together with your own imagination, will inspire you to create your own original fairy fashion house.

*A true wood nymph's outfit all in green*

*Stripy socks and polka-dot bloomers give a sense of fun and playfulness.*

*Flowers and berries are ideal for headdresses: lilac for spring; red or orange berries for winter.*

*A fuchsia flower is easily adapted to make a hat.*

*Leaves and grasses are twisted together to make a halter-neck dress.*

*Delicate satin slippers*

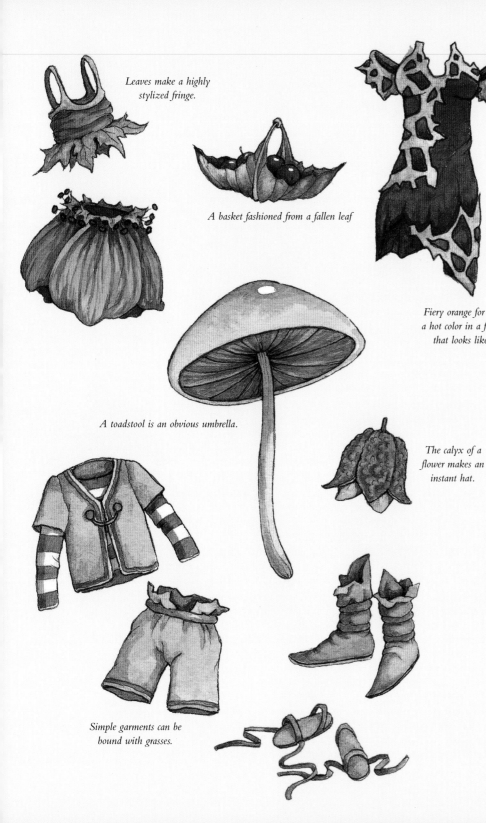

Leaves make a highly stylized fringe.

A basket fashioned from a fallen leaf

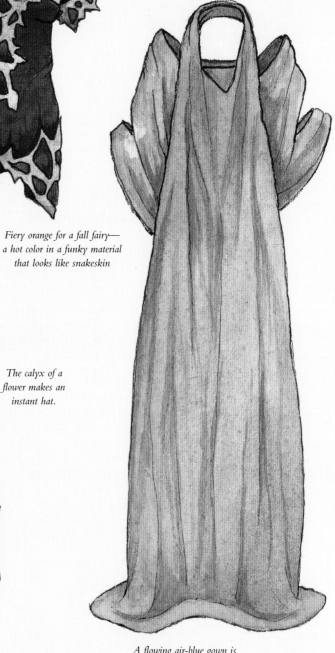

Fiery orange for a fall fairy— a hot color in a funky material that looks like snakeskin

A toadstool is an obvious umbrella.

The calyx of a flower makes an instant hat.

Simple garments can be bound with grasses.

A flowing air-blue gown is suited to a gentle mystic.

CONTINUED on next page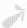

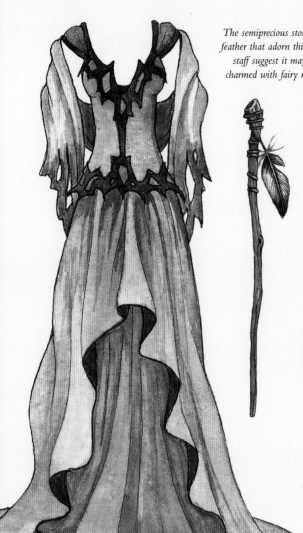

*The semiprecious stone and feather that adorn this twig-staff suggest it may be charmed with fairy magic.*

*Modest and simple bloomers and camisoles are suited to innocent child fairies.*

*Patches and ragged edges give a modest, humble look, or can reflect energy and mischievousness.*

*A lilac gown for an adult female gives the impression of peace.*

*Oversized buttons, cast off and left behind by humans, give an immediate sense of the fairy's diminutive size.*

*The bodice is the calyx from which the flower petals flare outward to form the skirt.*

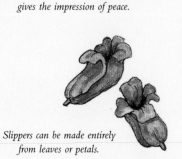

*Slippers can be made entirely from leaves or petals.*

*Ready to wear— an acorn-cup hat*

*Natural adornments give an instant fairy look.*

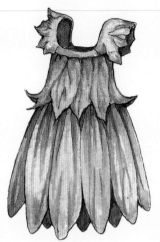

A short, pink petal dress is
suited to a playful girl fairy.

Garments made from petals
are soft and vibrant.

Celtic-style jewelry
gives the wearer an
air of mysticism.

Leaves make simple
hats that are ideal for
male fairies.

Victorian bodices lend themselves
to simple fairy style, adhering
closely to the body shape.

A warm cloak and festive berries
for a Christmas fairy

Stripes and hot colors
are bold and racy.

Cool colors are
soft and feminine.

Diaphanous fabrics lend
an ethereal beauty.

# HABITATS

Where do fairies live? They are most often portrayed as living with nature, inhabiting trees, sitting on toadstools, or making their homes in flowers. They can be seen almost anywhere in woodlands and fields—and, of course, at the bottom of your garden. You can imagine them anywhere you choose, even in your own house, though outdoor settings allow you to present them as part of the world of plants and flowers, utilizing all that nature has to offer, so that it only takes a little imagination to see what life might be like for a fairy. They probably live quite comfortably in and among hollow tree roots, in toadstool or mushroom houses, or in old birds' nests and hedgerows, using small twigs to make furniture, drinking from acorn cups, pressing leaves to use as tablecloths, bathing in rain-filled nutshells, and using the soapwort plant to make bubbles.

TOADSTOOLS:
BASIC TIPS

*This line drawing shows that the main shapes of the toadstool are very basic. The underside of the toadstool cap should be drawn with slightly curved lines radiating from the center. It's these that give the drawing its perspective and sense of dimension.*

# TOADSTOOL CLUSTER

1. THE BASIC SHAPES
   Roughly sketch out the initial shapes of your toadstools, adding any leaf shapes, grasses, and so on. Don't worry if you change your mind and have to make alterations; this is the sketching stage and doesn't have to be perfect.

2. ADDING SHADOW
   Once you are happy with the basic look of the image, you can then add some shading to help define the shapes and forms.

3. PAINTING THE TOADSTOOLS
   When adding color, keep things gentle and natural looking, thinking along the lines of fall shades and green mosses.

## Well-known fairy habitats

Two simple habitats have been chosen for this section—toadstools and flowers—and the drawings and captions give tips on how to create them. Toadstools are favorite places for fairies to sit on or shelter under when it rains, and they are a nice easy subject to begin with. Flowers, of course, provide a wider field of choices, and if you are painting a flower fairy you will have to decide which flower this fairy represents. If you find yourself short of inspiration, consider buying a selection of silk flowers, which are quite realistic nowadays, and are useful when fresh flowers are not available.

# Flowers

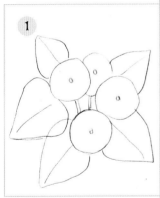

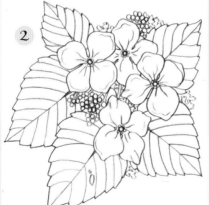

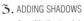

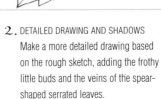

**1. BASIC SHAPES**
This flower is loosely based on the simple shape of a blue hydrangea. Start with an outline sketch of the basic shapes. This helps with the overall composition of the painting, letting you visualize the overall balance of shapes.

**2. DETAILED DRAWING AND SHADOWS**
Make a more detailed drawing based on the rough sketch, adding the frothy little buds and the veins of the spear-shaped serrated leaves.

**3. ADDING SHADOWS**
As with the toadstool, pencil in shading to give depth to the image. Putting in the tones also allows you to see how the finished painting will look, though you can still make alterations before adding the color.

**4. CHOOSING THE COLOR**
Hydrangeas are naturally pink, but gardeners take pride in encouraging them to take on a range of blues, such as the lovely lilac-tinged hue used here. Notice the variety of tones used, with darker color on the outsides of the petals to give them form.

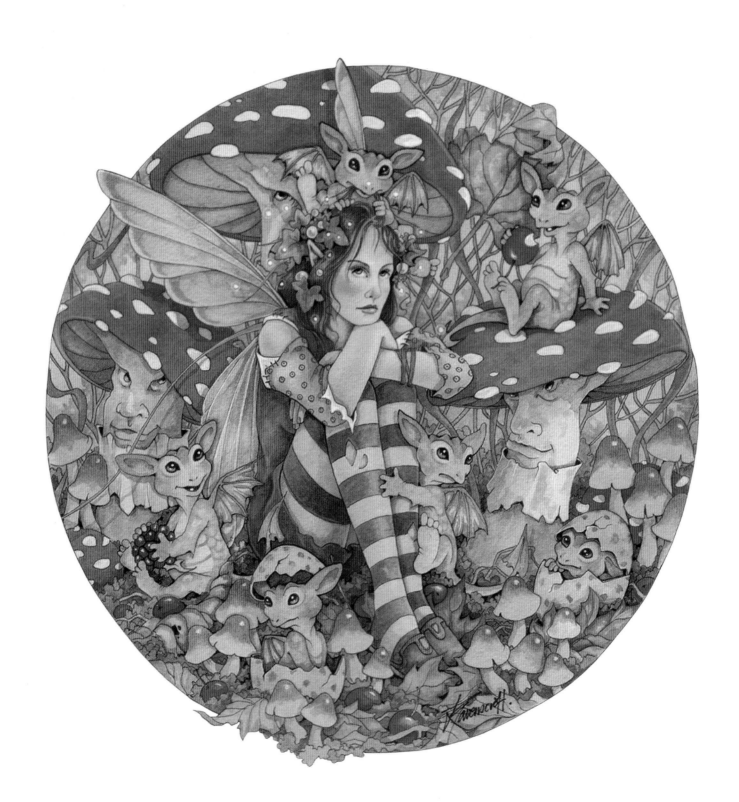

Chapter Three

# Techniques

# Basic Watercolor Techniques

Watercolor can be worked in two basic ways, wet-in-wet and wet-on-dry, and both methods can be combined in one painting or any specific area. In the first method, as the name implies, wet paint is laid over a wash or brushstroke that is still damp so that colors blend together. It can create magical effects, but it takes practice to learn how to control the flow of colors. The key is judging the dampness of the paper—too wet and the colors will mix completely so that they no longer have an individual identity, so wait until the

TRACE THIS!

**1. MAKING THE DRAWING**

Copy or trace this simple leaf design or make up your own. The lines need to be strong enough to show through the first washes, as the leaves are painted over the background. See page 27 for tips on enlarging the image.

### YOU WILL NEED

300-lb medium-textured (cold-pressed) watercolor paper, stretched
HB pencil for sketch
No. 6 round watercolor brush, or larger if you want to increase the scale
Watercolors: Payne's gray, olive green, yellow ocher, purple madder, sepia, and vermilion hue (or cadmium red).

**2. WET-IN-WET BACKGROUND**

Mix a wash of olive green and a separate one of Payne's gray, load your brush with the green and apply it in even strokes horizontally across the whole drawing, keeping on reloading the brush and applying it to the paper until it is nice and wet. Quickly wash the brush and load up with the Payne's gray, gently brushing it into the top left-hand corner and sweeping it through the green, leaving some of the former showing. Before the paint has dried, add some more green to the wash to make it stronger, and then drop in blobs of color. This should push away some of the previous color and create a running effect that looks very effective as a backdrop for fairies. Leave to dry.

**3. THE FIRST LEAVES**

You should still be able to see your drawn lines, but if not, reinforce them so that you can make out the leaf shapes. Prepare washes of yellow ocher, vermilion hue, and purple madder, load the brush with the ocher, and gently paint in the whole of the leaf shape using the tip of the paintbrush. Once it is covered, and while still wet, take some of the red and gently dab it into the yellow. Watch the effect it creates, and add more paint until you are happy with the effect, then use the purple on the edges of the leaves to give more definition.

**4. ADDING LEAVES**

As soon as the first leaves have dried, you can then proceed to paint in the others, using the same method as before, but taking care not to drop wet paint onto the dried leaves, as this would cause the new paint to spread into them. When all the leaves are dry, add some veins with the sepia, using the tip of the brush and a somewhat drier mix of paint, then add some grass stalks to provide additional interest.

sheen is off the paper. Wet-on-dry simply means applying new, hence wet, paint over a dry layer. This creates crisp edges, and is the best method for detail. Paintings are sometimes begun wet-in-wet to establish the main colors and then sharpened up with wet-on-dry detail. The important thing to remember is to wet only the areas you want the paint to run into and work as quickly as possible so that the washes don't dry out.

ADDING DEFINITION
This is an example of a more intricate image using similar methods to those described on the opposite page. The leaves have all been painted wet-in-wet, with some fine wet-on-dry brushwork, and the background is paler and less dramatic to allow the leaves more prominence—this was achieved by lifting out some of the wet paint with a tissue (see page 102). For the leaves, the paper was allowed to dry a little between washes, so that the color has spread only slightly, giving an extra vividness to the colors.

WET ON DRY
Most of this painting has been done with the wet-on-dry method. The image was drawn in pencil before a flat wash of pale olive green was painted over the whole of it. When this had dried the castle in the background was painted in using more of the olive green wash; this appears slightly darker because there are two layers of color. The leaves and rose were then painted with several overlaid washes of color, each being allowed to dry before the next was added.

SIMPLE EFFECTS
This is an example of very simple leaf forms painted using the wet-in-wet method. Experiment with very wet and just slightly damp paper to discover the different effects you can achieve.

# Laying washes

Watercolor is ideal for fairy paintings, allowing the artist to create soft, subtle backgrounds, fine, delicate effects, and exciting textures. If you are new to the medium, start by practicing laying washes, as these are the basis of all watercolor work. Washes can be large or small, can be laid on dry or damp paper, and can be done with wet-in-wet

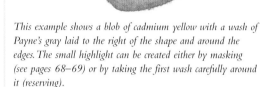

**WET-IN-WET**
*The center part of the leaf shows the wet-in-wet method. A wash of yellow ocher and burnt sienna was applied, and while still damp, purple madder and scarlet lake were added, allowing the colors to bleed into each other.*

*This example shows a blob of cadmium yellow with a wash of Payne's gray laid to the right of the shape and around the edges. The small highlight can be created either by masking (see pages 68–69) or by taking the first wash carefully around it (reserving).*

**BOTH TECHNIQUES USED TOGETHER**
*This side of the leaf shows both techniques used hand in hand. Colors were worked wet-in-wet on the main body of the leaf, as in the center segment, and when dry, details were added with a small brush as on the right-hand segment. Artists will often use both these methods together without forward planning or conscious decision.*

**WET-ON-DRY**
*A wash of yellow ocher and burnt sienna was laid first and allowed to dry before another one of the same color was laid over it with a small brush, providing detail to the edges of the leaves and veins.*

*Blends of permanent rose and ultramarine*

*Blends of scarlet lake and cadmium yellow*

*Blends of viridian and cadmium yellow*

COMBINING METHODS
This example shows how wet-in-wet and wet-on-dry washes can be used either on their own or together. The leaf has been built up with small washes, and for the right-hand segment the colors have been layered wet-on-dry.

WET-ON-WET WASHES
Experiment with small samples to see which colors blend successfully, as not all colors will look good together. These small, jewel-like shapes have been worked wet-in-wet with simple combinations of colors.

methods to make colors flow into one another, creating what is known as a variegated wash—these are often used for backgrounds or foliage. To create the samples shown here, the artist has worked on medium-textured (cold-pressed) watercolor paper using an oval wash brush.

See Also:
WATERCOLORS *page 11*
PAPER *pages 20–21*
IMPRESSING INTO PAINT *page 102*

**FLAT WASH**
All-over flat washes are used less often than the other types, but learning to paint them is an important skill to master. Here cerulean blue was applied in even strokes from the top of the paper to the bottom, making sideways sweeps of the brush. Either flat or round brushes can be used, and the paper can be damped in advance or used dry. It is best to prop the board at a slight angle to encourage each band of color to flow into the next.

**VARIEGATED WASHES**
Variegated washes are those in which two or more colors are laid together. They are worked wet-in-wet so that the colors bleed into one another. In this example, purple madder was applied to the top of the paper, and it was then turned upside down and a wash of cadmium yellow applied to meet the purple in the middle.

**DROPPING IN COLOR**
A wash of cadmium yellow and scarlet lake has been applied quite randomly to the paper, and then more intense drops of the scarlet have been dropped into the wet paint with the tip of the brush to create a mottled effect. This method is very useful for background effects or areas of foliage that don't need precise definition.

**LIFTING OUT COLOR**
This is the perfect method for clouds, and is one of the watercolor artist's vital tricks of the trade. Here a variegated wash of Payne's gray and purple madder with a little yellow ocher was laid all over the paper, and areas of color were then removed by dabbing into the wet paint with a tissue.

# MASKING FILM

Masking film, a fine, clear, sticky-backed plastic supplied on a roll and available from most art and craft shops, is useful for watercolor work. The glue on the back is very gentle and can easily be removed from most smooth-to-medium-surfaced watercolor papers. It allows the artist to protect large areas of work when using techniques such as stippling, sponging, and spattering, which can easily end up in the wrong places.

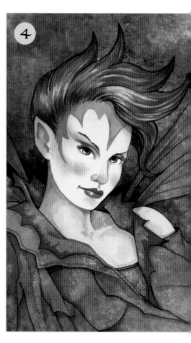

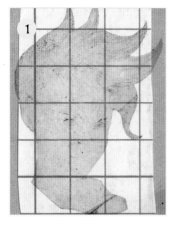

**1.** APPLYING THE MASK

Draw out an image using the pen rather than a pencil, as this will help you to see the drawing after the first washes have been applied. Paint in some of the flesh tone using a wash of raw umber to define the features, leave to dry, and then apply a rectangle of masking film. Carefully cut around the image with a fine blade, removing the excess.

**2.** STIPPLING THE COLOR

With the film in place, color can now be stippled on all over the image (see page 81). Mixes of cadmium yellow and vermilion hue have been picked up with the brush and then dabbed off onto absorbent paper to make sure the paint is not too wet—it needs to be fairly dry for this method. Continue to add layers of stippling until you have achieved the desired effect.

**3.** REMOVING THE MASKING

The paint has been left to dry and the film removed, leaving the skin and hair untouched by the stippled color.

**4.** FINISHING THE PAINTING

Complete the image by painting in the features and adding detail to the garments to make them stand out from the background. You can also go around the image with the pen to give it more definition if required.

## YOU WILL NEED

| | |
|---|---|
| 140-lb hot-pressed (smooth) watercolor paper | sepia, and gray |
| Sepia waterproof pen | No. 2 round brush and No. 6 bristle brush |
| Watercolors: raw umber, yellow ocher, cadmium yellow, vermilion hue, purple madder, | Masking film and sharp cutting knife (small blade) |

◄ OTHER MASKING METHODS

You can also make masks from objects or pieces of card cut to specific shapes and sizes. These can be kept in place as you paint either by holding them down or by fastening them lightly with masking tape. Exciting effects can be created in this way, and this example shows how something as simple as a pressed leaf can be used as a mask to protect the paper beneath.

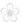

# Masking Fluid

Masking fluid is the easiest and most popular method of reserving highlights and masking off small areas of work in order to protect them from the paint. Masking fluid is liquid latex, which can be applied with a brush, pen, or thin stick—it is best to use an old or inexpensive brush and wash it immediately after use as once dried the latex can't be removed. It is best to apply the liquid quite quickly and not too thickly, as it dries better when thinly applied and is easier to remove later on. Unlike masking film, the fluid can be used with very wet washes, as there is no danger of the color seeping underneath, and it is easily removed when the paint is dry by gentle rubbing with an eraser or a fingertip.

## See Also:

STIPPLING *page 81*
LAYING WASHES *pages 66–67*

TRACE THIS!

**1. APPLYING THE MASKING FLUID**
Draw out a simple leaf shape, or you can copy or trace out the sketch shown here. Mark out the veins lightly with pencil and then use the old small brush to apply masking fluid along the lines of the veins. See page 27 for tips on enlarging the image.

**2. APPLYING THE PAINT**
Paint the leaf wet-in-wet as shown on page 66, using the No. 4 brush and washes of both the olive green and the burnt sienna.

**3. REMOVING THE FLUID**
When the paint has dried fully, the fluid can be removed. Here half of it has been rubbed off with an eraser.

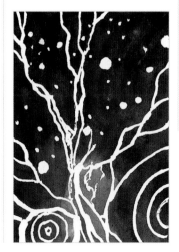

**4. TINTING THE WHITE**
Often you will find that when the fluid is removed, the masked areas appear much too white. This was the case here, so the artist has laid a thin wash of olive green over the whole image to create a softer effect.

◄ DRAWING WITH MASKING FLUID
This is a very simple sketch made by "drawing" directly onto the paper with masking fluid with a small brush. You can also use a pen or stick. Heavy wet-in-wet washes were applied on top of the fluid, and the masking fluid was then removed.

## YOU WILL NEED

Medium or smooth-surfaced watercolor paper
HB pencil for sketch
No. 4 round brush

Old No. 00 paintbrush (for latex)
Colorless masking fluid
Colors: olive green and burnt sienna

# USING WHITE GOUACHE

Because fairies are such ethereal creatures, it is often necessary to add a few little specks of magic dust and glittery effects. White gouache, the opaque version of watercolor, is perfect for this. Gouache is usually supplied in a tube, but some manufacturers also produce jars, and it can be used thickly to cover colors beneath or thinned down to

## PAINTING DEWDROPS

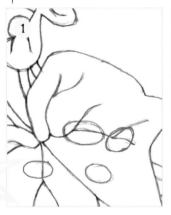

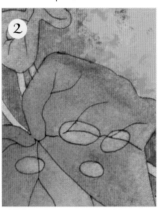

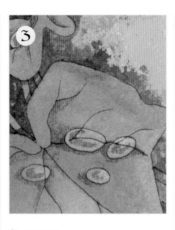

TRACE
THIS!

**1. MAKING THE DRAWING**
Copy or trace this template or make your own design, not forgetting to draw in the dewdrop shapes where you need them. See page 27 for tips on enlarging the image.

**2. APPLYING THE WATERCOLOR**
Paint the image with the No. 4 brush, starting with the background. Begin with olive green and cadmium yellow, and then add some viridian to create some depth. Mix together some olive green and viridian to create the color for the ivy leaf, and paint over the whole leaf, including the dewdrops.

**3. SHADING**
Using the fine brush and a wash of sepia, apply shading effects around the left side of the dewdrops and the leaf, and also add a little to the inside of the dewdrops, again to the left.

**4. USING THE GOUACHE**
Still using the small brush, apply a slightly watered down mix of white gouache to the inside edges of the dewdrops to make them stand out more, then use a much thicker mix of the gouache (almost direct from the tube, with just a little water added) to paint in clear white highlights. Here the sepia pen has been used to darken some of the leaf edges, thus drawing attention to the dewdrops.

### YOU WILL NEED

Watercolor paper of your choice
HB pencil or a fine-tipped sepia
    waterproof pen
No. 4 and No. 1 brushes
Watercolors: olive green, viridian,
    cadmium yellow, and sepia
White gouache

create softer effects. Some artists prefer white acrylic, but this cannot be removed once dry, so it has to be used with caution; it also has a tendency to stand out from the watercolor as a different texture. Gouache has properties similar to watercolor, and can be used hand in hand with it to create a number of useful effects.

# White Fur

**1. BASIC SHAPES**
Using this image as a guide, draw out the basic shapes and wash over the whole picture with raw umber, then add in the rest of the colors, allowing them to dry before adding more color to give extra depth. In this example, ultramarine and violet have been used on the cloak, lamp black on the hair, and a tiny dab of Payne's gray over the raw umber wash in the background. More raw umber has been added to the neckline and collarbone to give more definition, and some shadow created with a wash of lamp black. The collar itself is left as the original raw umber wash. It is important to complete most of the background coloring and shading first in order for the fur effect to work.

**2. STARTING WITH THE FUR**
Using the white gouache and the small brush, apply strokes following the direction of the fur, gradually adding more to build up the effect. The hairs on the outer parts of the collar overlap the cloak and hair, an effect that would have been impossible to achieve if these had not been painted first—you would have needed to place color between each individual hair.

**3. MASSED BRUSHSTROKES**
Here you can see the effect of the many small individual brushstrokes of opaque paint, which create a very realistic effect.

**4. COMPLETING THE PAINTING**
If you wish, you can echo the fur effect in other parts of the painting using the same technique. Here small circular shapes have been brought in to create little snowball effects suitable for a winter fairy. White gouache has also been used on the eyelashes and slightly watered-down white gouache has been used in the background to reinforce the theme of winter and snow.

## YOU WILL NEED

Watercolor paper of your choice
HB Pencil
No. 4 and No. 0 brushes
Watercolors: raw umber, Payne's gray, ultramarine, violet, lamp black
White gouache

# WAX RESIST

Wax resist is an exciting method to try, and can be very useful for textures such as those on bark, or for less specific ones in backgrounds. Wax resist works on the principle that watercolor slides off wax. Wax crayons work especially well with leaves and foliage, and you can also use pastel shades to draw in fairies' wings, giving them a transparent quality. The technique also works with oil pastels, although you do have to be careful because if you apply too much watercolor on top the resist effect will be lessened.

**1. THE CRAYON DRAWING**
Make a very faint pencil drawing as a guideline, and then redraw with the crayons. Here dark green was used for the main outline of the leaves and grasses; the inner sections of the leaves were lightly filled with yellow-green and some white to add highlights; black was used on the veins; and violet, red, and white were used on the berries themselves, with a yellow stalk added on the left.

**2. APPLYING THE PAINT**
Paint a wash of Payne's gray all over the image, and as it dries add more to the edges of the leaves to help outline them and make some of the background area slightly darker.

**3. ADDING DEFINITION**
When the paint has dried you can if you wish go around some of the details with a black fiber-tipped pen. This is optional, but as you can see from this detail, where only one group of berries has been outlined, it does help to strengthen the image.

**4. THE FINISHED IMAGE**
The combination of strong drawing and dark washes creates a rather moody look that might be suitable for a nocturnal fairy subject.

## YOU WILL NEED

Medium or smooth-textured watercolor paper
Inexpensive wax crayons: dark green, yellow-green, black, violet, red, white, and yellow

HB pencil
No. 8 round brush
Payne's gray watercolor
Black fiber-tipped pen (optional)

▶ SIMPLE EFFECTS
This is a very simple flower drawn in wax crayon in shades of pink, purples, and white overlaid with a wash of olive green. Experiment with simple drawings and different colors of paint.

# CREATING DEPTH

In any landscape painting, with or without fairies, it is necessary to give the impression of depth and recession, and the main way of doing this is to use brighter colors and stronger tonal contrasts in the foreground. A useful method of boosting the tonal contrasts is to use black for shadows, and since black watercolor tends to dry with a matt and muddy surface, ink is a better choice. Here, acrylic ink has been used because it is waterproof, and can be used for shading before the watercolor is applied.

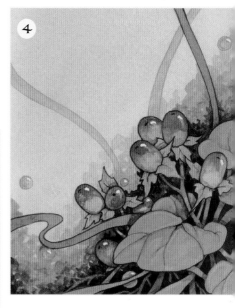

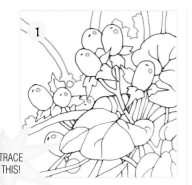

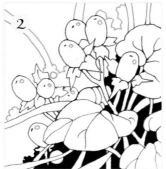

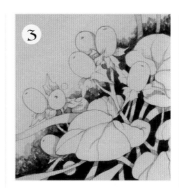

TRACE THIS!

**1. MAKING THE DRAWING**
Draw or trace the image as shown. You will find it helpful to do the main part of the drawing with the sepia pen and the rest in pencil, as this will allow you to differentiate between the two areas of the painting. One will be quite dark and vivid, and the other much paler, appearing to be further in the background. The paler blue lines shown in this drawing indicate where your pencil lines should be. When you have mastered this technique and can remember the separate areas of light and dark, you can draw the whole image in pencil if you prefer.

**2. PAINTING THE DARK AREAS**
Using the black acrylic, paint in all the darker parts of the painting, taking care not to get too carried away. Be selective and try to imagine the darkest parts of the painting as the foliage opens up toward the light.

### YOU WILL NEED

Smooth watercolor paper
HB pencil
Sepia waterproof fiber-tipped pen with 0.1 mm nib
Black acrylic ink
No.1 or No. 2 round brush for the ink
No. 8, No. 4, and No. 1 round brushes

Watercolors: olive green, dark olive green, viridian, cadmium yellow, purple madder, and Payne's gray
White gouache
Green colored pencil (optional)

**3. THE FIRST WASH**
Once the ink has dried, apply a wash of viridian to the whole of the image using the No. 8 brush, and when this has dried, add some olive green with the No.4 brush to suggest some of the outer foliage. Next add a wash of dark olive green to the foliage area; this will make the foliage darker at the base and paler as it rises up from the black ink. Use the dark olive green also to paint in more shading.

**4. THE LEAVES AND BERRIES**
Paint the leaves and grasses with a mixture of viridian and olive green to give them a vibrant glow, and color in the berries working wet-in-wet (see page 66). Here a small blob of cadmium yellow was surrounded by purple madder and allowed to blend, and the stems were painted with dark olive green and a hint of purple madder. Using the lighter olive green, add a little more foliage behind the berries, and paint in the stems penciled in at the drawing stage. If you wish, you can add a final touch by drawing in some small grasses in between the painted ones, working over the ink with the green colored pencil. In the completed painting the dark greens and strong black shadows bring the foreground toward the front of the picture, while the softer background seems to recede.

# PROJECT ONE: SPRINGTIME FAIRY

Suitably springlike colors have been used for this portrayal of a springtime fairy, together with several of the techniques covered in the previous section. These include watercolor washes, masking fluid, white gouache highlights, and black acrylic ink for depth.

## YOU WILL NEED

- Cold-pressed watercolor paper 140-lb or heavier
- HB pencil
- Sepia waterproof pen (optional)
- Black acrylic ink
- Colorless masking fluid
- Round watercolor brushes: No. 1, No. 6, and a large No. 16 wash brush

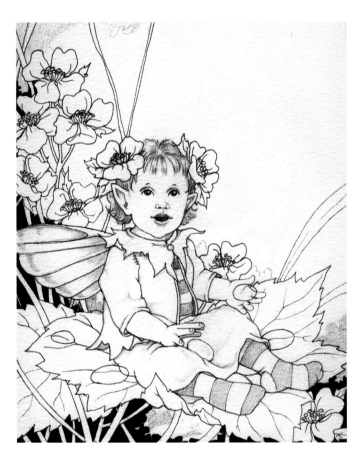

### 1. THE DRAWING

Sketch the composition with pencil, and then go over the drawing with the sepia pen. You don't have to do this, but it does make the image clearer and easier for you to follow each step. However, if you leave your drawing in pencil, simply following the steps, you will achieve a softer result. Paint in the shadows beneath the foliage with the No. 1 brush and the black acrylic ink.

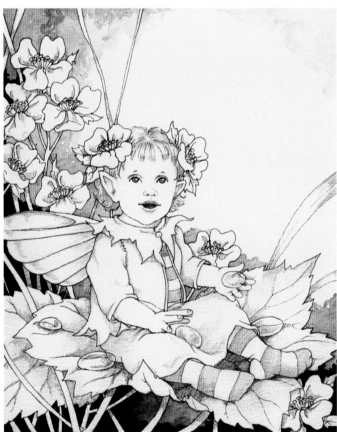

### 2. MASKING THE BLOSSOMS

Lay light washes of chromium oxide green around the outer edges of the painting to create a feeling of depth in the background, allow them to dry thoroughly, and paint masking fluid over the blossoms, adding a few small dabs to the leaves for dewdrops.

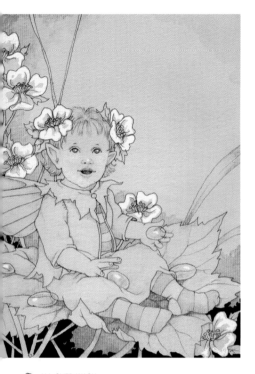

**3.** ALL OVER WASH

Paint over the whole image with a cobalt green wash using the No. 16 brush. Now you can see clearly where the masking fluid was applied. Remove the fluid when the wash has dried by gently rubbing with a finger, and then apply some more of the chromium oxide green to the background foliage.

**4.** PAINTING THE LEAVES

Paint a fairly strong cobalt green wash onto the leaves underneath the fairy and on the blossom stems and leaves, using the No. 6 and No. 1 brushes. When dry, darken the green by adding a little sepia, and use this for shadows underneath the fairy's skirt.

**5.** CLOTHING AND SKIN

The fairy's dress and wings and the blossom stamens are painted with green-yellow using the No. 6 and No. 1 brushes, and then the skin tone is added by painting on a wash of raw umber with the small brush. With the same brush, put touches of rose madder onto the lips, the tip of the nose, and the cheeks and ears, and then paint the eyes and inside of the mouth with a sepia wash.

## PAINTS USED

Watercolors:
- Oxide of chromium (chromium oxide green)
- Cobalt green
- Phthalo green
- Green-yellow
- Hooker's green

Acrylic paints and mediums:
- Raw umber
- Zinc white gouache

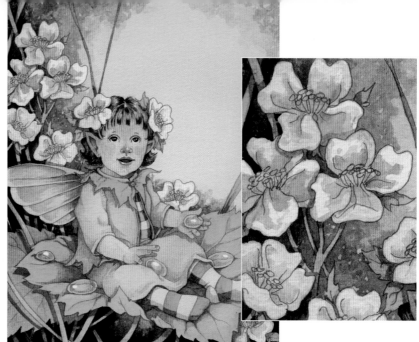

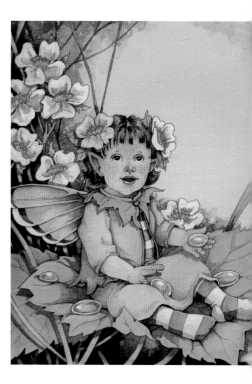

**6.** BUILDING UP

Still using the small brush and sepia, paint in the hair, and when dry, add shadows and detail with a darker mix of the same color. Paint a small highlight on the bottom lip with the white gouache, taking care with the placement. Paint the collar and stripes of the outfit with a wash of phthalo green, and fill in the grasses and stems surrounding the fairy with cobalt green and chromium oxide.

**7.** THE MAIN SHADING

Much of the shading is added in this step, with the small brush. Using Hooker's green and sepia, mix a dark wash, adding some Payne's gray for extra strength if desired. In this painting the sun is shining from the front of the top right-hand side, so that most of the shadows appear to the left. Don't forget to add depth underneath the fairy's skirt and clothing, and on the area of wing behind the shoulder. Give a little extra depth to the clothing and wings with the green-yellow, but leave the tips of the wings without added paint. Lay a very thin wash of rose madder over the blossoms.

**8.** ADDING WHITE

Using the No. 1 brush, paint white gouache onto the stockings and jacket, making them look more crisp and clean, and add more gouache on the blossoms, the tips of the wings, and the dewdrops. Paint little stripes on the wings using the previous shadow mix of Hooker's green and sepia, and put in fine highlights on the sleeves and jacket, and the pollen in the blossoms, with cadmium orange.

**9.** THE FINISHED
PAINTING
The polka dots on
the jacket were an
afterthought, as the
artist felt that the
fairy looked rather
too plain, and were
painted with Hooker's
green and the fine
No. 1 brush. They
finish off the painting
very well, and echo
the dark tones on the
hair and wings.

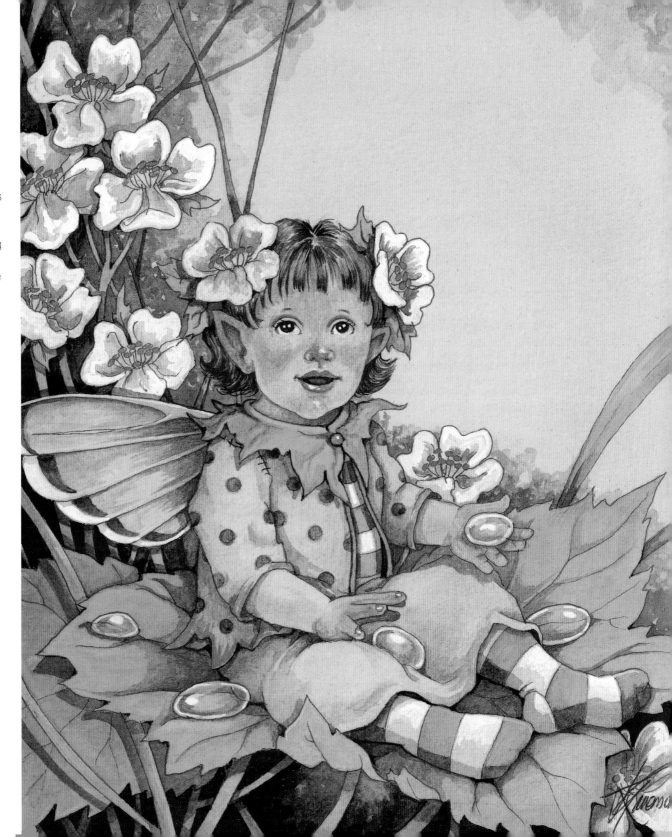

# COLORED PENCILS

Most people have probably used colored pencils during childhood, but many of those on the market today are of superior quality to those given to children, and are a pleasure to use. They can be combined with watercolors or used on their own, and are capable of a wide range of both subtle and bold effects. They can be blended together in a way similar to pastels, but are much less chalky and easier to manage.

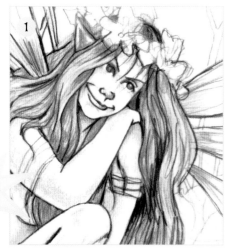

TRACE THIS!

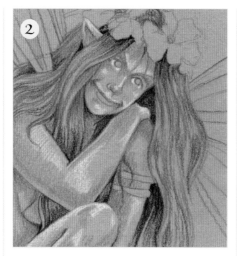

**1.** MAKING THE DRAWING

You can copy or trace this drawing (see page 27), or design your own fairy. Draw it using the sepia pencil; you can make a light drawing with an HB pencil as a guide if you wish, as colored pencil can't be erased easily.

### YOU WILL NEED

Deep beige pastel paper
Cotton swabs
Colored pencils: raw umber, sepia,
    white, dark brown, olive green,
    black, viridian, canary yellow,
    pink carmine, and sienna
Pencil sharpener
Fixative spray

**2.** THE SKIN TONES

The paper itself will create the basic skin tone, so you need only cover it quite lightly. Use the raw umber to create the medium tones, with sepia in the darker areas under the neck and hair and white for highlights on the limbs and face. Add a little raw umber, sepia, and sienna to the hair.

▶ DETAIL AND DEFINITION

This detail drawing shows how foliage drawn in colored pencil can be sharp and vibrant. Try adding canary yellow to the tips of the leaves and stems to brighten them up a little. Define some of the veins with white, and create a shiny effect on the left side of the leaf by rubbing the pencil over the whole of the leaf and pressing quite hard (this is called burnishing). Put in a few twigs in the background with the black pencil, and use this also to sharpen up the leaves and flowers.

**3.** BLENDING

Create a softer look by blending all the previous colors with the cotton swab.

You can draw with colored pencils on ordinary smooth drawing paper, but tinted pastel paper, which has a slightly rough texture, is also good, and has been used here. The advantage of the tint is that you don't have a lot of glaring white paper to cover. If you need white highlights you can use a white pencil. It is a good idea to spray finished drawings with fixative made for pastels.

## See Also:

COLORED PENCILS *pages 12–13*
PAPER *pages 20–21*
UNDERSTANDING COLOR *pages 22–26*

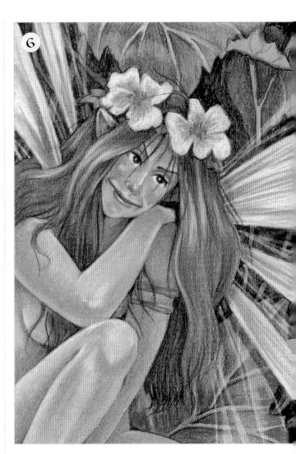

**4. BUILDING UP**
Give more definition to the eyes with black used for the pupils, and add a little more dark brown to the hair. Bring the face and body to life with pink carmine on the lips, cheeks, chin, and shoulders, and blend again. Add viridian to the background, and olive green to the stems and armbands. Use white and pink carmine for the flowers in the hair, with a touch of canary yellow for the centers.

**5. FINISHING TOUCHES**
Continue to build up the facial features, and add more sepia and sienna to the hair. Strengthen the background with black and viridian, and color the leaves with olive green. On the wings, create a semitransparent effect by laying white over the background color.

**6. THE COMPLETED IMAGE**
The completed image shows something of the possibilities of this attractive medium. Don't forget that colored pencils can also be used over dry watercolor, so you can often save a not-quite successful watercolor by drawing over it.

# DRY BRUSH

The technique of dry brush involves applying a minimum of paint to the paper. After loading the brush, dab it onto tissue paper until it is almost dry, then swipe the brush over the chosen area so that the color catches only on the top grain of the paper without sinking into it. This method is very useful for suggesting subtle foliage effects such as grasses or distant wheatfields—add a few spots of red and you have a poppy field. You can use watercolor brushes for this method, but some artists prefer a flat bristle brush, which gives a more dramatic texture.

SEE ALSO:

MASKING FLUID *page 69*
BRUSHES AND PALETTES
*page 18*

1
COPY
THIS!

2

3

**1. MAKING THE DRAWING**
Copy or trace the flower sketch or design your own. Make the pencil drawing strong enough to be seen through the first wash, as the flowers are to be masked out later.

## YOU WILL NEED

Medium or rough-textured
    watercolor paper
HB pencil
Colorless masking fluid
Watercolors: olive green, viridian,
    cadmium yellow, and burnt sienna
White gouache
No. 8 and No. 1 watercolor brushes and
    a chisel-shaped No. 10 bristle brush
    (or any fairly stiff paint brush)

**2. DRY BRUSHING THE GRASSES**
Using the No. 8 brush, lay an olive green wash over the whole picture, and when dry add more olive green to the leaves and stems and roughly paint in the center of the daisies with cadmium yellow. Cover the whole of each flower with masking fluid (see page 69), leave to dry, and then, using the bristle brush, dry brush diagonal, slightly curving strokes of viridian from left to right. Repeat the process twice to create a sense of depth.

**3. PAINTING THE FLOWERS**
When the paint has completely dried, remove the masking fluid and paint in the petals with white gouache, touching up the centers with some olive green. Add some touches of burnt sienna around the edges near the petals.

▼ DRY BRUSH STROKES
This simple image suggesting snow falling among foliage shows the possibilities of the dry brush method. A simple olive green flat wash was applied to paper and allowed to dry before a mix of viridian and dark olive green was dry brushed over it with a bristle brush partially dried on tissue paper. A few spots of white gouache were added to create some atmosphere—very easy and effective.

# Stippling

This is a wonderful method to use for creating specific textures, for giving subtle effects to foliage or clouds, or for filling in large areas of background. It can be a messy technique and is not suitable for use around delicate fairy figures or other important features unless you can mask the area off first, as shown on page 68. Stippling is a very enjoyable and liberating way to paint, suitable for any painting medium. For the best effects, you will need a bristle brush, or any fairly stiff brush.

**1. PAINTING THE TOADSTOOL**
Draw out the toadstool and foliage, using this image as a guide, and paint it before you start the stippling. Use scarlet lake for the toadstool cap, raw umber for the stem, and olive green and warm gray for the foliage.

**2. BEGINNING THE STIPPLE**
Mask the painted area with film or cut paper. Mix a strong wash of cobalt blue and load up the bristle brush, dabbing off any excess on tissue paper, then apply the paint using a repeated stabbing action, keeping the brush almost upright as you work. Reapply the paint as necessary in the same way, leaving some of the white paper showing through.

**3. BUILDING UP**
Clean and dry the brush, then mix separate washes of yellow ocher and olive green. Starting with the yellow, randomly apply the color as before, repeating as necessary, and then repeat the process with the olive green. Work around the left-hand edge of the painting, leaving some of the blue clearly visible center right.

**4. FINISHING TOUCHES**
The painting could be left as it is at this stage, or you can add more layers of stipple to give the impression that the toadstool is deep in a wood. Here viridian and purple madder have been laid over the previous colors, still using the stippling method. When the paint has dried, remove the masking and add small touches such as floating seeds with the white gouache. If required, define a few details with the sepia pen.

## YOU WILL NEED

Medium-surfaced watercolor paper
HB pencil
Sepia waterproof fiber-tipped pen with 0.1 mm nib (optional)
No. 1 watercolor brush and an inexpensive No. 14 bristle brush

Masking film or paper to cut mask
Watercolors: scarlet lake, yellow ocher, olive green, viridian, purple madder, cobalt blue, raw umber, and warm gray
White gouache

◀ STIPPLING WITH SEVERAL COLORS
This sample gives an idea of how successive layers of stippling with several colors can create exciting and atmospheric effects.

# PROJECT TWO: SUMMER FAIRY

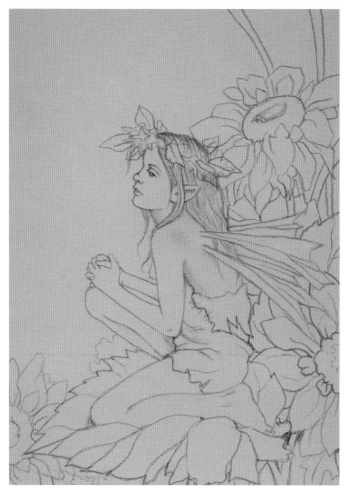

This little summer fairy crouching among brilliant red sunflowers was created using a typical warm-colored summer palette and a selection of the techniques demonstrated in the previous section. Masking film and dry brush stippling was used for the background, and the rest of the image was completed with the colored pencils and blending techniques.

## YOU WILL NEED

- Cream-colored pastel paper, fastened to a board with masking tape
- Large bristle brush for stippling—a small decorator's brush or stiff paintbrush
- Masking film and sharp cutting blade
- Cotton swabs for blending
- Good-quality pencil sharpener
- Zinc white gouache and a No. 1 brush
- Hooker's green and yellow ocher watercolors

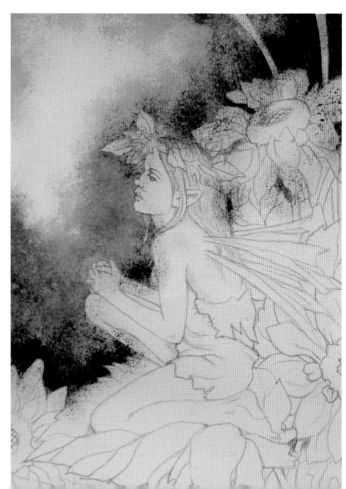

### 1. THE DRAWING

Tape the paper to a drawing board, which will allow it to take a small amount of watercolor without it buckling (pastel paper will not take heavy washes), then draw the design with the brown pencil, using fairly light pressure. Any mistakes can be hidden by the subsequent applied colors.

### 2. THE STIPPLED BACKGROUND

Cover the whole of the drawing with the masking film and carefully cut around the edges of the figure and sunflowers. Start to stipple the background with the Hooker's green watercolor, using a stabbing action and making sure that the brush is not too wet—always dab off any excess paint on some tissue or scrap paper before applying it. Repeat the process with the yellow ocher to create a frame around the drawing.

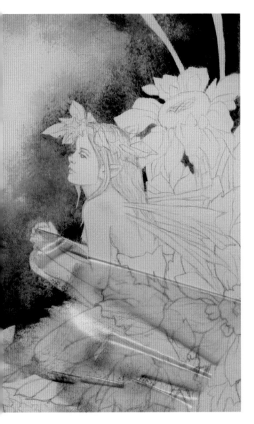

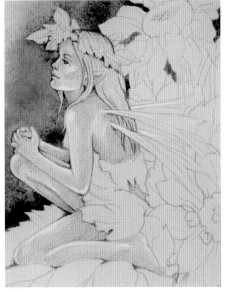

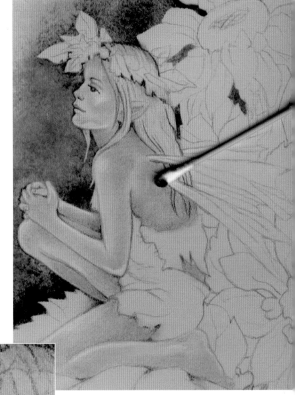

**3.** REMOVING THE FILM
Remove the masking film when the paint has dried thoroughly. Here you can see how well the drawing has been protected from the paint.

**4.** COLORING THE FIGURE
Using the raw umber, white, and pink carmine pencils, gently color the figure, concentrating on the fairy's back—because of the cream-colored paper there is no need to color the whole of the body. Add highlights on the shoulders and front of the face with the white pencil, applying firm pressure, and put in touches of pink carmine on the tip of the nose and cheeks.

**5.** BLENDING
Gently blend the colors together using a cotton swab, taking care not to rub too hard. The skin tone should look nice and smooth, with the white highlights still quite visible.

## COLORED PENCILS USED

- Walnut brown or medium brown
- Raw umber
- Dark sepia
- Hooker's green
- Light green
- Sap green
- Olive green
- Chrome orange
- Yellow ocher
- Cadmium yellow
- Vermilion
- Pink carmine
- White
- Light blue

### 6. COLORING THE FLOWERS AND FOLIAGE

Using cadmium yellow, vermilion, and chrome orange, color in the flower petals, using the paler color nearest the center of the flower, and running outward through chrome orange to the bright vermilion around the edge. Blend the colors with the cotton swab, then use the dark sepia pencil to define some of the petals and to draw in the tiny seeds and the inside centers of the flowers. Use this also to enlarge the fairy's eyes, and then add some sap green on the headdress and the stems of the sunflowers. For the foliage, use olive green at the bottom of the drawing underneath the main leaf and on the shaded parts of the leaf itself, and light green on the other main leaves and stems. Add darker shading just behind the fairy with Hooker's green, and draw in the flowers on the headdress with vermilion and chrome orange. Give more depth of shadow to the leaves beneath the sunflowers using the dark sepia pencil and blending it into the olive green at the bottom of the drawing and on the fairy's dress where her arms are resting.

### 7. BUILDING UP THE COLORS

Color the hair, dress, and wings with the cadmium yellow pencil and gently blend with a cotton swab. To build up the depth of color and make the outfit look warmer in tone, add raw umber and yellow ocher on top of the cadmium yellow and again blend. Draw in the hair with raw umber and some of the walnut brown, making careful strokes that follow the natural flow, and then add more sap green to some of the stems and grass stalks at the top of the picture.

### 8. COLOR ACCENTS

To brighten up the fairy's dress, add some vermilion to the edges of her tunic, repeating these color accents on the tips of her wings. Apply a little extra pink carmine on her cheeks and lips.

**9.** THE FINAL TOUCHES
To complete the picture,
first brush over the
background with a light
blue pencil and blend the
edges, adding extra twigs
with the dark sepia pencil,
and then put in tiny floating
pollen grains using the
No. 1 brush and the
white gouache.

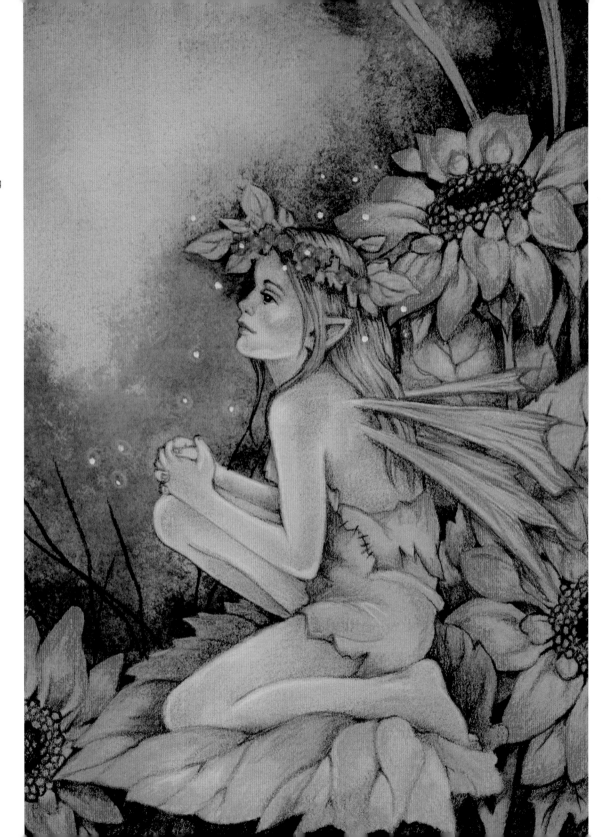

# ACRYLIC BACKGROUNDS

Acrylic paint is a very versatile medium to work with, either on its own or in combination with watercolor or other media. Although it can resemble oil paints when used thickly, it can also be used in thin washes or at a medium consistency, and can achieve a remarkable degree of detail as well as a wide range of textures. Like watercolor, it is diluted by mixing with water, but unlike watercolor, it cannot be removed once dry,

## WATERCOLOR OVER ACRYLIC

 TRACE THIS

**1. MAKING THE DRAWING**
Copy or trace this simple group of toadstools and autumn leaves (see page 27) or create your own design. If you draw in pencil, it is very important to overlay the pencil lines with the pen afterward, as otherwise the drawing will become lost beneath the first application of paint.

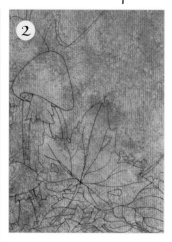

**2. THE STIPPLED BACKGROUND**
This is where the fun starts. Squeeze a small blob of each of the acrylic colors onto a plate, then put a large blob of gel retarder in the center of the plate. Using the bristle brush, take up a small amount of the yellow ocher together with a good scoop of the retarder, and mix them on another plate. You should aim at a ratio of about 1 part paint to 2 parts retarder, as you don't want the color to be too dense, and the retarder will make it more transparent. Stipple the yellow all over the drawing, using the technique shown on page 81, and repeat the process with the other colors, applying them fairly randomly. Allow some of them to mix, but, for interest, leave some blobs of individual colors, such as the viridian in the top right-hand corner and the blobs of burnt sienna toward the bottom.

**3. ADDING THE WATERCOLOR**
Once the paint has dried, if you have not used it too thickly, you should still be able to see the pen drawing well enough to paint over the acrylic with the watercolors and the No.1 brush. Use the colors as thick and dry as possible, almost straight from the pan, starting with yellow ocher and burnt umber on the leaves, then viridian on the foliage background and grass, and raw umber and purple madder on the toadstools. The colors should be allowed to blend together, as they naturally will, as the acrylic makes the watercolor glide on rather than being soaked up. Finally, define the outlines with the sepia pen and add some floating white pollen grains with the white gouache.

### YOU WILL NEED

Smooth or medium-surfaced watercolor paper
Sepia waterproof fiber-tipped pen with 0.1 mm nib
Acrylic gel retarder
No. 14 bristle brush and No. 1 watercolor brush
Paper plates for mixing

Acrylic colors: raw umber, burnt sienna, yellow ocher, and viridian
Watercolors: yellow ocher, burnt sienna, raw umber, purple madder, viridian, and sepia
White gouache

which rules out any washing-off methods. It also dries much faster than other paints unless a special medium called a retarder, available in art supply stores, is used to slow down the process, so wet-in-wet applications are trickier than with watercolor. The examples shown here demonstrate two very easy ways to use acrylic paints in backgrounds: one uses a stippling method in acrylic with watercolor painted on top, while the other shows a layering method in which intensity of color is built up with successive glazes.

# Acrylic Glazes

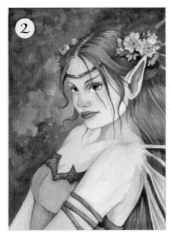

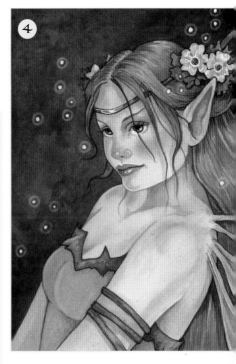

## 1. FIRST STEPS

This painting is quite complex, so if you want to try out the method on something simpler you can just draw a leaf or flower shape in the corner of your paper and follow Steps 2–4. However, copy the image if you feel sufficiently confident, and start by using the watercolors to paint in the features. Raw umber has been used for the skin tone, burnt sienna for the hair, olive green and a touch of viridian for the eyes and flower leaves, permanent rose for the flower, and Payne's gray for the headband and eye details.

## 2. ACRYLIC BACKGROUND

Squeeze a small blob of each acrylic color onto a paper plate, load the No. 6 watercolor brush with water, mix up a wash of viridian acrylic and paint it over the paper. Using all the colors in turn, continue to lay on washes, making sure that you use the tip of the brush to go carefully around the drawn lines, as acrylic can't be washed off. You can't soften untidy-looking hard edges either, but don't worry too much about these, as they will be hidden as the painting progresses.

## 3. LAYING THE GLAZES

Still using the acrylic paints, mix viridian and a dab of olive green with water to make a glaze. It is called a glaze rather than a wash because it is applied over the top of the already dried paint, creating a new semi-transparent layer. Each layer is worked wet-on-dry, and the more glazes you apply the deeper and more opaque the finish will become. Here two glazes of the viridian/olive mix have been applied over the whole of the background area, deepening the red while still allowing it to show through.

## 4. TIDYING UP

The background now looks much more even than it did in Step 2, as the hard edges have been covered by the second and third layers of glazing. Complete the painting by drawing around the edges with the sepia pen, and adding highlights with white gouache and the No.1 brush.

### YOU WILL NEED

Medium-surfaced watercolor paper
HB pencil or sepia waterproof
    fiber-tipped pen
No. 6 and No.1 watercolor brushes
Paper plates for mixing
White gouache

Watercolors for hair and eyes (optional):
    burnt sienna, raw umber, Payne's
    gray, olive green, viridian, and
    permanent rose
Acrylic paints: viridian, yellow ocher,
    cadmium yellow, and vermilion

# PEN AND WATERCOLOR

This is a wonderful combination of mediums, as it allows you to combine fine linework with delicate watercolor washes. There are many different methods, and a vast selection of art pens available. This example uses a fiber-tipped sepia ink pen, which lets the ink flow more freely than a fountain pen, and the light brown creates a subtler line than black that

SEE ALSO:
PEN AND INK *page 19*
PAPER *pages 20–21*
LAYING WASHES *pages 66–67*

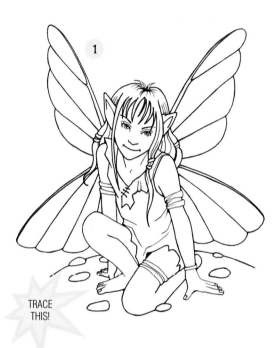

TRACE
THIS!

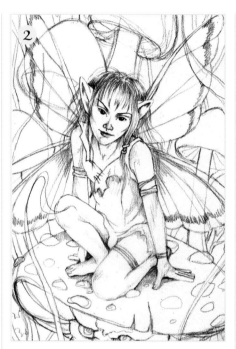

**3.** INKING
When you are happy with the sketch, draw over the main lines with ink. Draw the main outlines only of the hair, and don't do too much inking on the face—restrict yourself to the line under the nose, the line through the center of the lips, and the eyes, which will be more intense. When the ink is dry, remove the pencil lines.

**1.** TEMPLATE TO TRACE
Trace this fairy figure onto stretched watercolor paper or a watercolor block. You can then draw around it with a sepia pen and erase the pencil lines, or use it as a basis for a different treatment. You might try watercolor combined with colored pencil or work on rougher paper on a larger scale for a broader, more Impressionistic effect. See page 27 for tips on enlarging the image.

**2.** INITIAL SKETCH
Sketch your design very lightly in pencil, adding rough shading and highlights when you are sure the drawing is correct. Avoid drawing over any areas that are to remain white or pale colored.

## YOU WILL NEED

Smooth watercolor paper stretched onto board (see page 21)
HB pencil
Eraser (soft white)
Sepia ink pen: 0.1 mm nib

Watercolors: raw umber, olive green, viridian, permanent rose, vermilion hue, purple madder alizarin, and lamp black
No. 1, No. 2, and No. 4 brushes

marries better with the watercolors. Some artists prefer water-soluble ink, which runs slightly when the washes are applied, but this is a personal preference and you will find your own as you try out different methods and drawing implements.

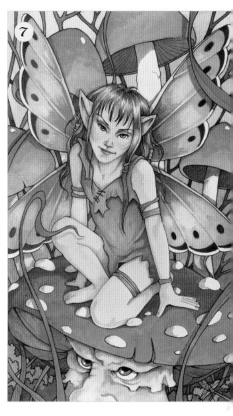

**4. LAYING WASHES**

Using the No.1 brush and a mix of raw umber and olive green, add the shadows to the face and body. The light source is in the top right-hand corner in front of the fairy, so the shadows will be over to her left side. You can draw into the picture at any time providing the washes are dry— wash over the newly drawn elements with the same colors, using a tissue to dab off any excess until you get the depth of shade required. Add patterns to the wings with diluted lamp black, and use a light wash of the same color for the undersides of the mushrooms. With a pencil, sketch background foliage, inking over the lines when satisfied. Add a little raw umber to the bottoms of the toadstools.

**5. FACIAL FEATURES AND HAIR**

Begin with pale washes and build up color gradually. Using the small brush and a mix of raw umber and olive green with a tiny drop of lamp black, add detail to the eyelids, nose, and chin. Use ultramarine for the eyes, and paint the cheeks with diluted permanent rose, using a stronger mix for the lips. Paint lowlights in the hair with raw umber, reserving white highlights for a glossy appearance. Apply layers of wash until you have a balance of light and dark.

**6. CLOTHING**

Paint the dress olive green, adding small dabs of viridian while still wet so that the colors blend together. Use fairly strong viridian and the small brush to paint the armbands and leg bracelet, then switch to the small brush and mixes of viridian and ultramarine to paint wings and hair ties, varying the tones to give a sheen to the wings.

**7. COMPLETING THE IMAGE**

Using the No. 2 brush, color the mushrooms and the red spotted toadstool with a wash of vermilion hue, carefully avoiding the white spots. Give the tops of the mushrooms a wash of purple madder alizarin, and while this is still wet, add a wash of raw umber to the bottom sections, allowing both colors to bleed together. Add some olive green to the bottom of the painting for more depth. Using a wash of lamp black, strengthen the details in the wings, and intensify the shading on the toadstool beneath the fairy's feet. Lastly, ink over all of the lines again using the sepia pen to give your picture a crisp clarity.

# ACRYLIC AND OIL PASTELS

Oil pastels are slightly clumsy to use, and not capable of very fine detail, but they are excellent for background effects, especially when used in combination with acrylics, and also allow you to create some lovely effects on the fairies themselves, such as gossamer wings. You can make interesting patterns, too, by drawing or scratching into thickly applied oil pastels to reveal a color beneath, in a method known as inscribing, or sgraffito. You can also use oil pastels over watercolors to add extra touches, such as magical wings drawn in iridescent metallic pastels on a dark painted background.

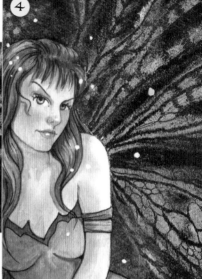

**1. ACRYLIC BACKGROUND**

Paint the fairy first, in watercolor. Or you can practice the technique without the figure if you prefer, and bring it into a finished painting when you have fully mastered it. With or without the fairy, start by painting a simple acrylic background as a backdrop for the wings.

**2. OIL PASTEL**

When the acrylic is dry, apply the silver and pearl oil pastels quite thickly in rough wing shapes, working from the shoulder area outward; don't worry if the effect looks a little untidy at this stage.

**3. BLENDING**

Smudge the colors together and blend them outward, using a cotton swab or your finger. You may have to press quite hard, as oil pastels are harder to blend than soft pastels.

**4. INSCRIBING**

The blending has produced a semi-transparent effect, but the wings still lack definition. Use your knitting needle or similar inscribing tool to draw in scales and veins, revealing the dark ground color beneath. The effect is much neater now, and the wings look both magical and realistic.

## YOU WILL NEED

Medium-surfaced watercolor paper
Acrylic paints: viridian, deep olive, and
      ultramarine
Oil pastels: silver and iridescent pearl
No. 6 watercolor brush
      (for the acrylic background)
Knitting needle or other
semisharp instrument

◄ **OIL PASTEL OVER ACRYLIC**
Indenting, or sgraffito, is a method often used for oil-pastel work. Here a simple acrylic background has been laid, with oil pastel applied thickly on top. Flame colors have been chosen to represent a fire sprite. A black-line drawing was then created by drawing into the oil pastel with a semisharp implement. A variety of effects can be achieved in this way depending on the colors chosen for the background and oil pastel layers.

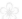

# PAINT SPATTERS

Spattering creates a random speckled effect, and while you can't always be sure of the final result, it is fun to do and well worth trying. Paint can be spattered by loading a watercolor brush with paint and tapping the handle quite hard so that the paint flies off the end of the hairs onto the working surface. Or you can use a bristly brush such as an old toothbrush, load it with paint, hold it bristle-side down and rub your thumb, a ruler, or kitchen knife across the bristles. This method is slightly more accurate, and produces finer spatters that can be ideal for snow, floating pollen grains, and, of course, fairy dust.

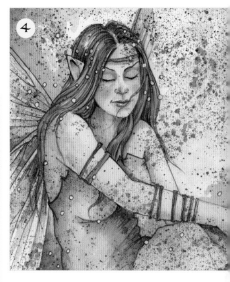

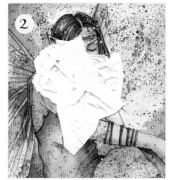

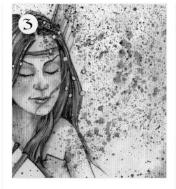

**1.** SPATTERING A BACKGROUND
When you are happy with the general feel of the technique, think about adding it to a painting. Here it is used for a pretty, windswept fairy, which you can trace or copy if you like (see page 27).

**2.** CONTROLLING THE SPATTER
To avoid getting the whole of the image covered with the spatters, you can mask the fairy's face and body with film or a paper template as shown on page 68, or you can simply hold a tissue over it. A selection of colors can then be used for the spattering; here both fine and coarse spatters have been used.

**3.** ACCIDENTAL EFFECTS
If some of the spattered paint lands on the face and arms, this doesn't matter, as it adds a little more realism, giving the impression of pollen being blown around on the breeze.

**4.** FINISHING TOUCHES
A little white gouache was added in the final stages to create some extra pollen, mainly on the clothing.

## YOU WILL NEED

Medium-surfaced watercolor paper
No. 8 watercolor brush
Old toothbrush
Watercolors: Hooker's green, cadmium yellow, ultramarine, and other colors of your choice

▶ PAINT SPATTER ON DRY WASH
First, a dry pale flat wash of cobalt blue was spattered with a heavy wash of ultramarine using an old toothbrush. More spatters of Hooker's green and viridian were added by tapping the handle of a loaded brush. These spatters are larger than those made with the toothbrush.

◀ SPATTER INTO WET WASH
Lay a variegated wash and while still very wet, reload the brush with Payne's gray and tap the handle to release the paint. The gray spreads out and gives a soft effect.

# PROJECT THREE: AUTUMN FAIRY

This lovely autumn fairy sitting among the just-turning leaves is painted in the warm hues typical of the season, with dark tones used to give additional atmosphere.
A selection of the techniques shown on the preceding pages has been used, including the acrylic background, spattering, and pen and watercolor for the figure. Acrylics are perfect for backgrounds, and because they are waterproof when dry, several layers of thin washes can be painted over one another. These are called glazes, and the more you apply the deeper and richer the color appears.

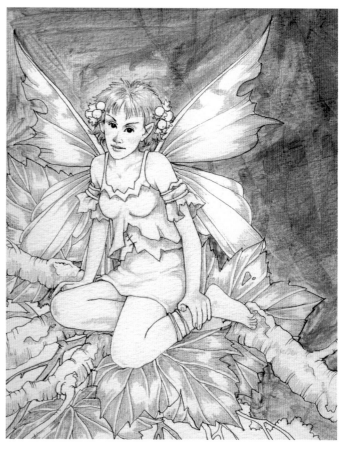

**2.** STARTING THE BACKGROUND
Using the No. 6 brush and a wash of raw umber acrylic (mixed with a little gel retarder to slow down the drying time), cover the whole of the background, carefully avoiding the figure. Don't worry if the paint looks streaky, as it will be covered by further layers.

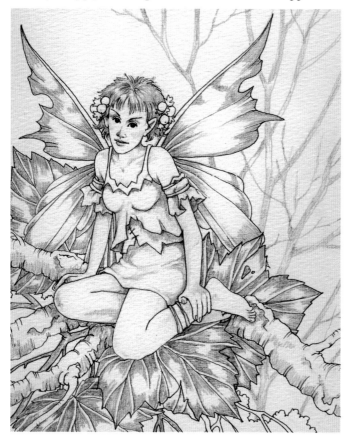

**1.** THE DRAWING
Draw out the design in pencil, then use the sepia pen to draw around the outline of the figure and leaves, leaving the background twigs in pencil. Add extra details to the foliage and figure with the pencil and bring in some shading, which will show through the watercolor washes.

## YOU WILL NEED

- Cold-pressed 140-lb watercolor paper
- HB pencil and sepia waterproof pen with a fine 0.1 mm nib
- Watercolor brushes: No. 1, No. 4, and No. 6
- Piece of scrap paper and scissors
- Zinc white gouache
- Old toothbrush for spattering

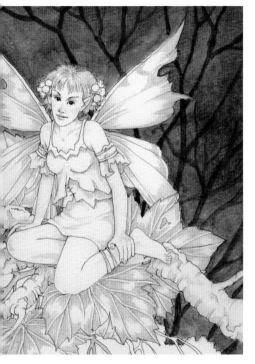

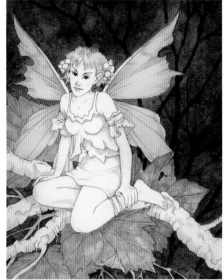

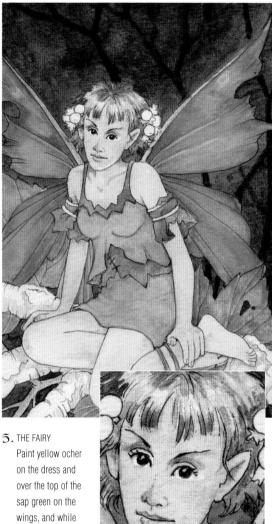

**3.** GLAZING TO BUILD UP COLOR

While the pencil lines for the twigs are still visible, go over them with the No. 4 brush and a thicker mix of sepia acrylic. When dry, apply a glaze of chromium oxide green acrylic with the No. 6 brush, allowing some of the original color to show through in places. Now apply further glazes of Indian red, raw umber, and a little yellow ocher, painting them on quite roughly and in patches to create a mottled effect, with more color in some places than others.

**4.** THE FOLIAGE

Watercolor is used for the rest of the painting. Paint a wash of sap green mixed with a small amount of dark olive green watercolor onto all of the leaves using the No. 6 brush and lifting out a few highlights before the wash has dried. The pen and pencil drawing provides most of the modeling on the leaves. Paint a very pale wash of sap green on the fairy's wings with the No. 4 brush.

**5.** THE FAIRY

Paint yellow ocher on the dress and over the top of the sap green on the wings, and while still slightly damp add Venetian red to the edges of the clothes and wingtips to give an orange glow. Using the No. 1 brush, paint a light wash of sepia onto the rest of the garments, the undervest, and arm decorations. Add some detail to the hair, and when dry, paint a wash of raw umber over the skin with the No.1 brush—raw umber is an excellent color for skin tones.

## PAINTS USED

Acrylic paints and mediums:
- Raw umber
- Sepia
- Chromium oxide green
- Yellow ocher
- Indian red

- Acrylic gel retarder

Watercolors:
- Raw umber
- Sap green
- Dark olive green
- Venetian red

- Yellow ocher
- Sepia
- Warm gray
- Alizarin crimson
- Payne's gray
- Rose madder

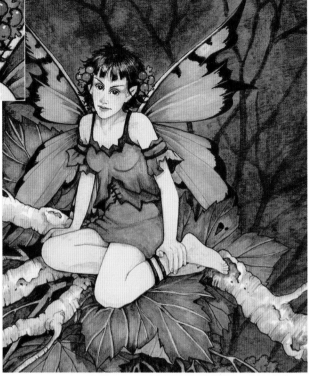

**7.** ADDING DETAIL AND COLOR

Using a deep mix of sepia with a little Payne's gray, apply details to the wing tips and add some striping to the top edge, using the No. 1 brush. Add any extra deep shadows if they are needed. Paint a little rose madder onto the fairy's face, cheeks, and tip of her nose. Using the No. 1 brush, add a wash of Venetian red to the tips and veins of the leaves to give them a more autumnal feel, and then apply more sepia to the fairy's outfit. Use a very dark mix to define the armbands and stitching across the front of the dress, and intensify the tones and colors of the hair with the same mix. Paint alizarin crimson on the edge of the jacket and on the berries on the headdress, leaving tiny white highlights, and paint the lips with the same color.

**6.** PAINTING THE SHADOWS

Make a mix of warm gray and Payne's gray, and still using the small brush, paint the shadows on the twigs and branches beneath the fairy. To give more dimension to the branches, apply small washes of the same mix with a little more of the warm gray added. Make another mix of Payne's gray and dark olive green and use the No. 4 brush to make the shading underneath the leaves and on the fairy's outfit, noting that the light source is at the top of the painting in front of the figure.

**8.** SPATTERING

Roughly draw and cut out the shape of the figure from the scrap paper to mask it from the spattered paint—you don't have to be too accurate as long as the paper shape fully covers the fairy. Mix some white gouache into a milky consistency, then load up the toothbrush, place it over the image, and spatter with droplets of paint. Continue until you are happy with the result, then remove the masking.

**9.** THE FINISHED PAINTING
The dark tones and rich colors of the background show the pale body and glowing colors of the wings to best advantage, and the spattered white paint suggests the stars emerging as the night draws in.

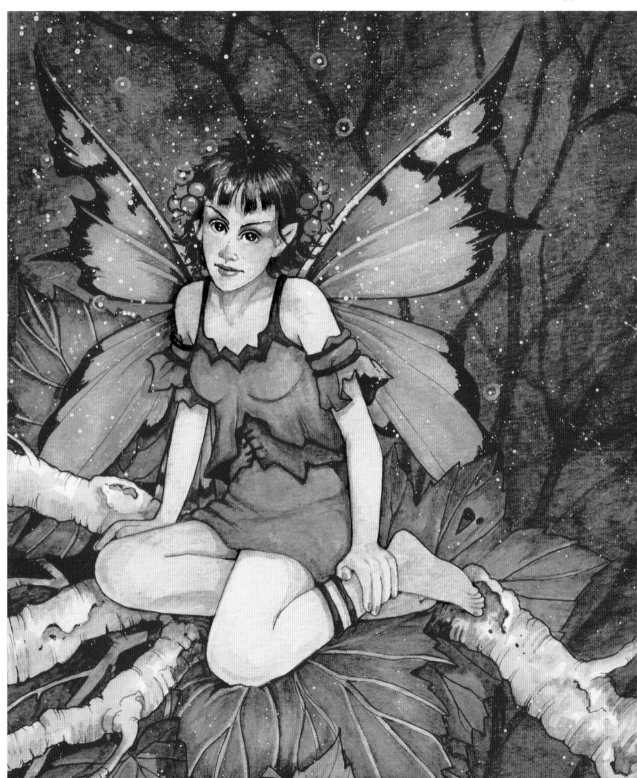

# ACRYLIC AND GOUACHE

Mixing acrylic and gouache is ideal for building up dark, rich colors. Because acrylic is waterproof, it makes a good background for water-soluble gouache, as it does for watercolor (see page 86), and depth of color can be built up very quickly. With this technique the gouache must be applied quite thickly over the acrylic to make it adhere to the waterproof surface, and it needs to be applied in layers. Although time consuming, the effects can be stunning—because the gouache is semi-opaque it seems to glow, and the paint becomes very bright, especially when using white or other more opaque colors.

**1. BACKGROUND AND LEAVES**
Paint the background using the No. 8 brush and heavy washes of ultramarine, burnt sienna, and viridian acrylic applied in layers until a smooth effect has been achieved. When dry, paint the stalks with cobalt green gouache and the No. 2 brush, using firm but simple strokes, then add each of the leaves in one stroke by pressing down on the brush so that it lies almost flat and then flicking it back up.

**2. PLACING THE FLOWERS**
Decide where the flowers are to go, and lightly mark their centers with cadmium yellow gouache.

### YOU WILL NEED

Medium-surfaced watercolor paper
No. 8 and No. 2 brushes
Acrylic colors: ultramarine, burnt sienna, and viridian
Gouache colors: white, cobalt blue, cobalt green light, and cadmium yellow

**3. PAINTING THE FLOWERS**
For the flowers, use cobalt blue gouache with just a little white, using the shape of the brush to create the shape of each of the five petals around the center. Mix cadmium yellow with cobalt green and add some tiny little flower buds and a few extra highlights on the stalks and leaves.

▶ **HEDGEHOG**
This painting was produced by the same method as the flowers, but took considerably longer because of its intricate nature. It was worth the effort, however, as it has enabled the artist not only to build up fine detail but also to capture the effect of deep night, which is the natural setting for this nocturnal creature.

▼ **DAISIES**
This simple image showing daisies with grasses and floating pollen grains has been painted with gouache over a dark acrylic background.

# WATERCOLOR PENCILS

Watercolor pencils are a wonderful invention, suitable both for professionals and amateurs, easy to carry around, and very straightforward to use. They are ideal for anyone who is comfortable with drawing but has little experience painting with watercolors. They can be used dry, in the same way as colored pencils (see page 78), but can be brushed over with water to produce a line-and-wash effect. You can mix colors together by blending them on the paper surface, and you can also use them with or over watercolors—they are very useful for adding detail and depth in the later stages of a painting.

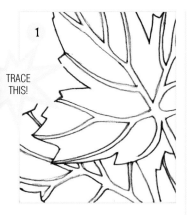

TRACE THIS!

**1. MAKING THE DRAWING**

You only need a simple image to practice using colored pencils, so either copy this leaf drawing or design your own. Use the umber-colored pencil for the drawing so that it will blend in with the later colors.

## YOU WILL NEED

Smooth (hot-pressed) watercolor paper
No. 2 and No. 4 watercolor brushes
Watercolor paint: raw umber
Colored pencil: raw umber
Watercolor pencils: raw sienna, olive green, dark olive, yellow-green, viridian, cobalt green deep, and chromium orange

**2. FIRST COLOR STAGE**

Using the No. 4 brush, apply a wash of raw umber watercolor over the whole image, and allow it to dry before adding raw sienna, olive green, and dark olive watercolor pencil around the leaves. Blend some of these colors by brushing over them with water; here water has been added to the colors in the bottom right-hand side to show the effect.

◀ WET AND DRY
This simple color bar shows the pencils applied in a dry state (top) and blended with water (bottom).

**3. BUILDING UP**

Add more water to the background to blend, then start to work on the leaves. Those at the bottom left have been colored in yellow-green, with viridian for the darker areas, and the main leaf has been colored with viridian and a little cobalt green. The veins have been left as the original raw umber wash. Blend the colors with water where needed; here the right-hand side of the main leaf has been blended while the left side has not, so that you can see the difference.

**4. WET AND DRY APPLICATIONS**

Using the No. 2 watercolor brush, wash over each leaf individually, just lightly skimming over the veins so that they remain paler. To make them show up more strongly, wait until the washes have dried and then use the very dark cobalt green to strengthen the outline of the leaf veins, but do not add water. Go around the edges of the leaves with chromium orange to give a golden glow, wet the small paintbrush, and wash the color up through the greens into the raw umber wash. When dry, draw in grasses with the dark cobalt green, leaving these pencil marks dry.

# PASTELS AND PASTEL PENCILS

Pastel sticks and pastel pencils are very similar, though the latter are slightly harder than traditional soft pastels, and being a thin stick encased in wood, like a graphite pencil, are less suitable for covering large areas. But they can achieve much more detail than soft pastels, which are relatively clumsy and crumble easily, and can be sharpened with a pencil sharpener to a fine point. Both pastels and pastel pencils are best worked on a

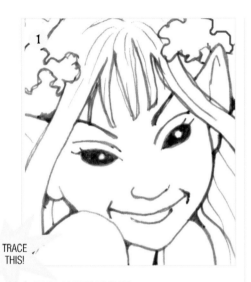

TRACE THIS!

### 1. PENCIL DRAWING TO TRACE

You can trace or copy this image or design your own fairy face, keeping it fairly simple. Draw it in white pastel pencil, as shown in Step 2, so that it shows up clearly on the gray paper. The white will also blend with the other colors and provide highlights here and there.

### 2. THE SKIN TONES

Using the image as a guide, add some raw umber to the face under the hairline and eyes, and give white highlights to the eyes. Use the paler cream for the center of the brow area and cheeks and pink carmine for the cheeks, nose, chin, and lips. Put in some sepia in the eye sockets, under the chin, and in the hair. Blend all of the colors together using a cotton swab.

### 3. BUILDING UP

Notice how smooth the image looks now that the colors have been blended. Using sepia and raw umber, fill in more of the hair, blending it with a cotton swab, and draw in the eyes with a well-sharpened black pastel pencil, avoiding the highlights put in earlier. Add ultramarine and white to the headdress and blend them in.

### YOU WILL NEED

Warm gray pastel paper
Pastel pencils: white, sepia, raw umber, cream,
     pink carmine, black, violet, and ultramarine
White pastel crayon
Cotton swabs
Fixative spray

◄ THE EFFECT OF BLENDING
These samples show how pastels blend together when they are smudged with a cotton swab or finger.

textured surface because the pigment tends to fall off smooth paper. Several types of pastel paper are available, made in a range of colors (pastels are usually worked on a pre-colored surface rather than white), but you can practice by using an inexpensive drawing paper, one which has enough grain to hold the pigment. Bear in mind that pastels smudge very easily, so it is wise to spray finished work with fixative.

SEE ALSO:
PAPER *pages 20–21*
UNDERSTANDING COLOR *pages 22–26*

4. ADDING DEPTH
Add more sepia and black to the hair and a little extra raw umber, pink carmine, and cream to the face in the same areas as before. Blend the colors to create more depth, and put in subtle white highlights, blending again if they stand out too strongly. Define details where needed with black or sepia, and then put in some white sparkles on the headdress.

5. CREATING AN AURA
To create an aura, draw roughly around the fairy's hair with a white pastel crayon, leaving some of the paper showing in between. Blend the white pastel using a cotton swab with outward strokes, creating a soft halo effect around the fairy.

6. THE FINAL TOUCHES
Complete the image with some final white sparkles. When you are satisfied, spray with fixative.

# PEN DRAWING

The pen is a wonderful drawing implement. Weighing almost nothing, it is ideal for outdoor sketching, and is equally well suited to producing full-scale fairy illustrations with a slightly Victorian flavor, to which you can add color later. Considerable depth of tone can be achieved by the hatching and crosshatching methods, texture can be suggested by scribbled marks, and although it does take a little practice to get the line work right, it is a liberating and enjoyable drawing

## PLANNING THE PICTURE

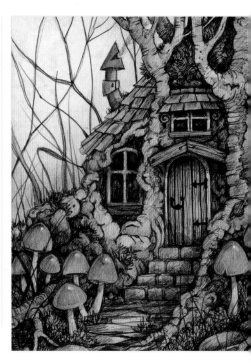

**FROM SKETCH TO FINISHED WORK**

These pictures show the stages of the complete illustration: first, the rough sketch made for the full image; second, the completed drawing; and third, the drawing with more pen detail and watercolor added. The combination of pen and watercolor is very attractive, giving the work a traditional fairytale look.

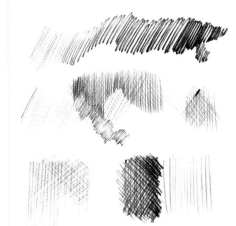

◄ PRACTICING MARKS

Before making a finished drawing in pen, practice hatching and crosshatching strokes, starting with light to dark as shown here. Hatching strokes are those that all follow roughly the same direction, while in crosshatching a second set of strokes crosses over the first. The closer the lines, the darker the shading becomes. Once you have gained confidence you can move on to the toadstool illustration, opposite.

### YOU WILL NEED

Black ballpoint or other waterproof pen
Heavy drawing paper or illustration board
Small selection of watercolors

method. There are many drawing pens on the market, so you will also need to experiment to find the one that suits you best. But for a start, try out the effects you can achieve with the humble ballpoint pen. This is an excellent drawing implement, allowing you to make both faint and dark lines according to the pressure used, and it has the additional advantage of being familiar.

# Working the Detail

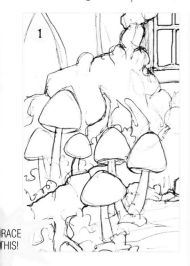

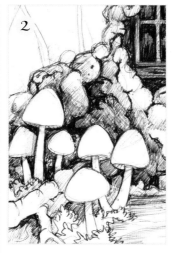

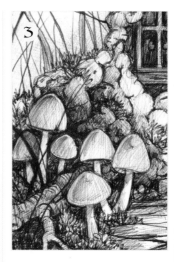

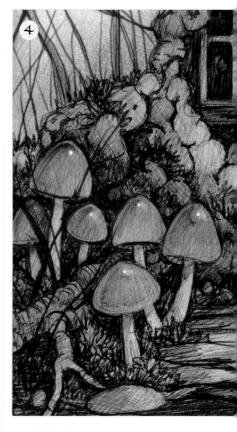

TRACE THIS!

1. STARTING THE DRAWING

Using a pen, draw out the design using light sketchy lines, just enough to create your outline and make the shapes visible. Don't worry if you make a few mistakes, as most of these rough lines will be integrated into the drawing when the detail is applied, but do keep the lines as pale as possible. See page 27 for tips on enlarging the image.

2. BUILDING UP TONE

Begin to build up depth of tone behind the toadstools, using the hatching and crosshatching methods applied with medium pressure, and making the areas behind the toadstools quite dark so that they show up well. Draw in the tree root in outline, indicating the form with a few small curving lines.

3. FORM AND DEFINITION

Continue to build up the tones to increase the depth of the image, taking care to use only very light hatching strokes for the toadstools, which must remain light in tone. Draw horizontal lines to define the floor area, and make scribbling marks for the foliage around the tree root. Add a few very dark wispy strokes to give the effect of delicate grasses and twigs.

4. ADDING COLOR

You don't have to add color to pen drawings, but watercolor washes do help to bring the image to life by separating and picking out details. Here only four colors have been used: raw umber, olive green, viridian, and purple madder alizarin and a little dab of white gouache for the highlights on the toadstool caps. Parts of the image that had originally merged together, like the small window at top right, are now much more visible, and the toadstools look more realistic.

# IMPRESSING INTO PAINT

Impressing works most dramatically with acrylic or oil paints, although some good effects can be achieved on damp watercolor washes, especially if the colors are vivid.

A piece of scrunched paper or other material is pressed down hard onto paint that is still damp, and as it is removed it leaves an impression in the surface. You can use all sorts of materials, such as sponges, baking foil, shrink-wrap, twigs, or leaves. It's a rather unpredictable method, but it is excellent for adding texture and interest to backgrounds.

**1. LAYING THE COLOR**
From each tube, squeeze out a decent quantity of color onto the paper plate, adding a similar amount of retarder to slow down the drying time. Using the No. 14 brush, apply each color in turn in a random way until the whole area is covered. The paint needs to be nice and thick, so only use a minimum amount of water.

**2. IMPRESSING**
Scrunch up your chosen paper, press it quite hard onto the surface, and then lift it off, taking care not to move it around or you will just get a smudged effect. If you try this once or twice you will see that you get a different effect each time.

**3. LIFTING THE PAPER**
As you can see, the crumpled paper has removed a lot of the paint, creating an attractive mottled effect that might suggest foliage. Darker colors would be ideal for conjuring up a stormy sky.

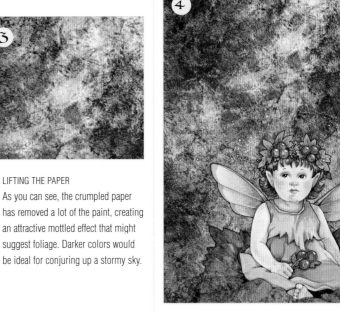

**4. PUTTING THE METHOD IN CONTEXT**
Although this method is not suitable for fine detail, it can provide an exciting setting for a delicately painted fairy as long as the figure is masked out with film first (see page 68).

## YOU WILL NEED

Medium-surfaced watercolor paper
Acrylic paints: olive green, viridian, turquoise, raw umber, and yellow ocher
Acrylic gel retarder (see page 15)
No. 14 bristle brush
Paper plates for mixing
Plain newsprint or similar paper

◄ IMPRESSING INTO WATERCOLOR
This is an example of impressing done in the same way onto a watercolor background, with the color still damp when the paper was pressed down into it.

# SALT SPATTER

This is a well known and easy watercolor technique, which creates magical effects. Salt is sprinkled onto wet paint, and as the salt touches the liquid it instantly absorbs some of it, creating a star- or flowerlike effect ideal for both fairies' wings and backgrounds. The salt and paint must be allowed to dry thoroughly before brushing off. The salt can be either placed precisely or thrown on randomly, but the effect itself is rather less predictable, which is what makes the technique so exciting.

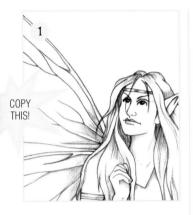

COPY THIS!

**1. TEMPLATE TO TRACE**
Draw or trace the design or create your own, but don't worry too much about the figure as the main point of this exercise is to practice the spatter technique. See page 27 for tips on enlarging this image.

## YOU WILL NEED

Medium-surfaced watercolor paper
HB pencil
Table salt
No. 8, No. 4, and No. 1 round brushes
Watercolors: olive green, viridian,
  Prussian blue, raw umber,
  Payne's gray, rose madder
  alizarin, and sepia
White gouache for highlights

**2. SALT SPRINKLE**
Apply an olive green wash to the background area only, using the No. 8 brush, and sprinkle the salt into it while still wet. When dry, add a little viridian to the top edges of the painting to give some depth, and start to paint the figure with the No. 1 brush, using raw umber for the skin tone and Payne's gray on the hair. Remove the salt when fully dry by brushing it off with your fingers.

**3. PAINTING THE WINGS**
Paint a wash of Prussian blue on the wings and dress with the No. 4 brush, and apply the salt as before. When dry, remove the salt and add more viridian to the background. Put in further detail on the figure, using the fine brush and raw umber again for the skin, rose madder alizarin on the lips and cheeks, and more Payne's gray on the hair, then darken the eyes with a mix of Payne's gray and sepia.

◀ MIXED COLORS
A mixture of colors, painted wet-in-wet, creates intriguing effects. Purple lake and violet have been used for this example.

▶ THICK APPLICATIONS
Here the salt has been scattered thickly and shows up well on the deep color.

**4. COMPLETING THE PAINTING**
Paint in any final details required with the small brush. Here some twigs were added for extra interest, white gouache was used to paint the veins on the wings, and some small snowflakes were added, also with gouache, to reinforce the effect of the salt spatter.

# PROJECT FOUR: WINTER FAIRY

## YOU WILL NEED

- Cold-pressed 140-lb watercolor paper
- HB pencil
- Black fine-tipped ballpoint pen
- Round No. 1 and No. 6 watercolor brushes
- Salt for scattering
- Zinc white gouache

This painting of the Winter Fairy Queen was created using the basic winter color palette and some of the previously mentioned techniques such as ballpoint pen, watercolor pencils, and salt scattered into watercolor washes. The painting is dark in tone, giving the fairy a somewhat somber, Gothic appearance suitable to her cold season.

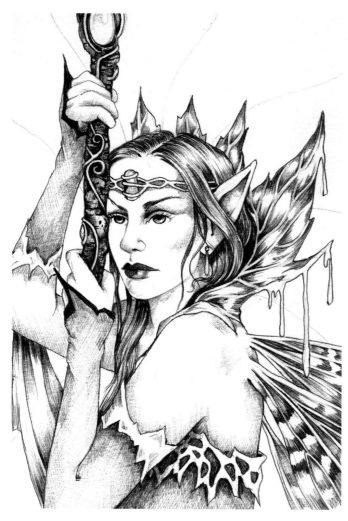

**1.** THE DRAWING

Make the initial drawing in pencil, and then begin to draw in the details with the ballpoint pen, establishing the main areas of tone by shading and cross-hatching. Don't draw over any pencil lines in the background, as these must be left faint.

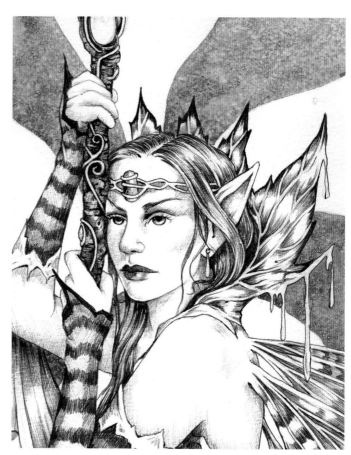

**2.** STARTING THE BACKGROUND

Add more ink shading to the bodice and draw in the stripes on the sleeves to provide extra interest. Mix a wash of cobalt blue and apply it to the background, painting one section at a time and leaving areas of white paper as shown. While the paint for the first section is still very wet, sprinkle the salt into it, and allow it to dry before painting in the next section.

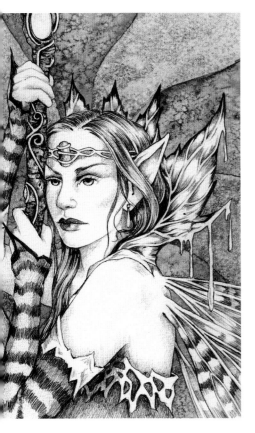

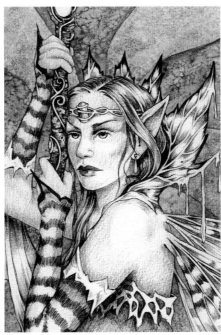

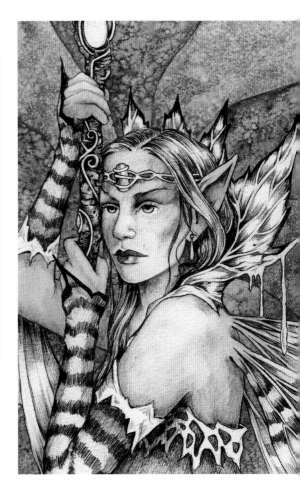

3. BUILDING UP THE BACKGROUND

Repeat the process using a wash of ultramarine and then adding some cerulean blue and allowing the colors to bleed together. Again, work on one section at a time to ensure that the paint remains wet enough to add the salt. When fully dry, remove the salt with your fingertips, using the blunt side of a craft knife for any stubborn grains that may have stuck to the paint. As you build up the applications of paint and salt, the definition of the pattern increases.

4. USING THE WATERCOLOR PENCILS

With the raw umber pencil, carefully color in some of the fairy's skin, leaving white paper for highlight areas such as the shoulder and parts of the face. Avoid coloring the icicles as you work on the picture, as these are achieved purely by allowing the white paper to shine through.

5. BLENDING

Dip the No. 6 brush into clean water and wipe off the excess on the side of the water container (you need the brush to be wet but not dripping). Paint over the penciled areas, taking some of the wet color into the highlight areas. Aim for a soft, watercolor-like effect but don't blend so thoroughly that you lose the pencil marks altogether.

## COLORS USED

| Watercolor paints: | Watercolor pencils: | |
|---|---|---|
| • Cobalt blue | • Raw umber | • Turquoise green |
| • Ultramarine | • Magenta | • Jade green |
| • Cerulean blue | • Ultramarine | • Lemon yellow |
| | • Imperial purple | • Blue-gray |
| | | • Sepia |

**6.** PAINTING THE FACE

To make the skin look colder, apply magenta watercolor pencil very lightly to the face, the tips of the ears and parts of the body, and then use the small brush and clean water to blend it gently into the skin tone. Color the eyes with ultramarine, add a little of the same color to the lips, and lightly blend again—just a touch of water applied with the small brush is all that is needed.

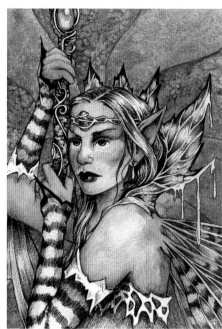

**7.** CLOTHING AND WINGS

Color parts of the collar, wings, and scarf with a mixture of ultramarine, jade green, turquoise green, and a little lemon yellow. Use ultramarine and lemon yellow for the gemstones on the fairy's headdress and staff.

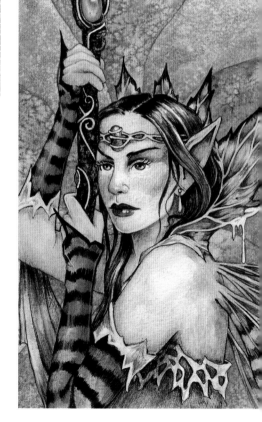

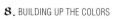

**8.** BUILDING UP THE COLORS

Blend the previous colors with the small brush as before, and then color in the stripes on the fairy's sleeves with ultramarine and blend lightly again before coloring the bodice with imperial purple.

**9.** DETAIL AND DEFINITION

Blend the purple of the bodice and then color the fairy's staff with a sepia pencil. To knock back the stark white of the lace, color lightly over it with jade green, and add a little blue-gray to the hair to create more depth of color.

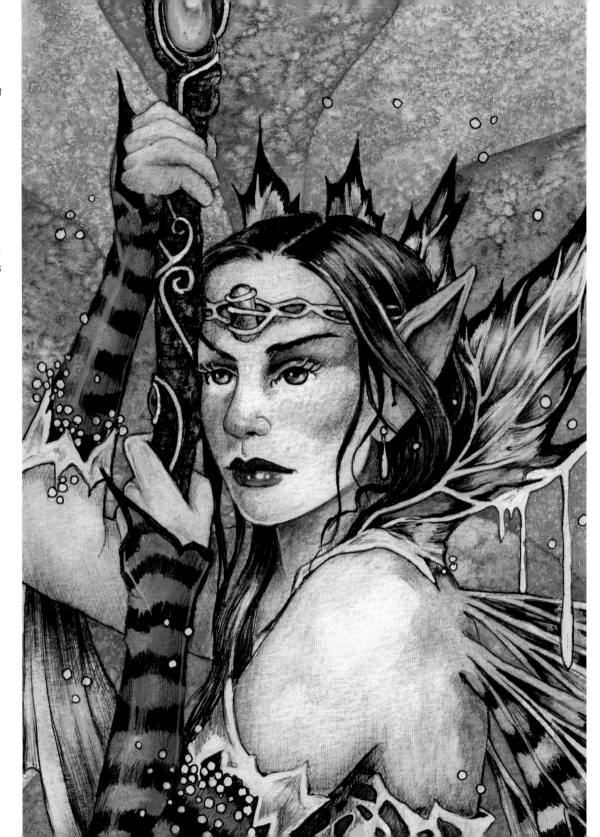

**10.** FINISHING TOUCHES
Blend all the previous
colors, then add a touch of
raw umber to the
headdress and the
wirework on the staff to
give the impression that
they are made of gold.
Add some wintry
highlights and snowflakes
with white gouache and
the small brush, and use
the gouache again to paint
the eyelashes and sparkles
in the eyes. To make the
snowflakes stand out
more, draw around them
with the ballpoint pen.

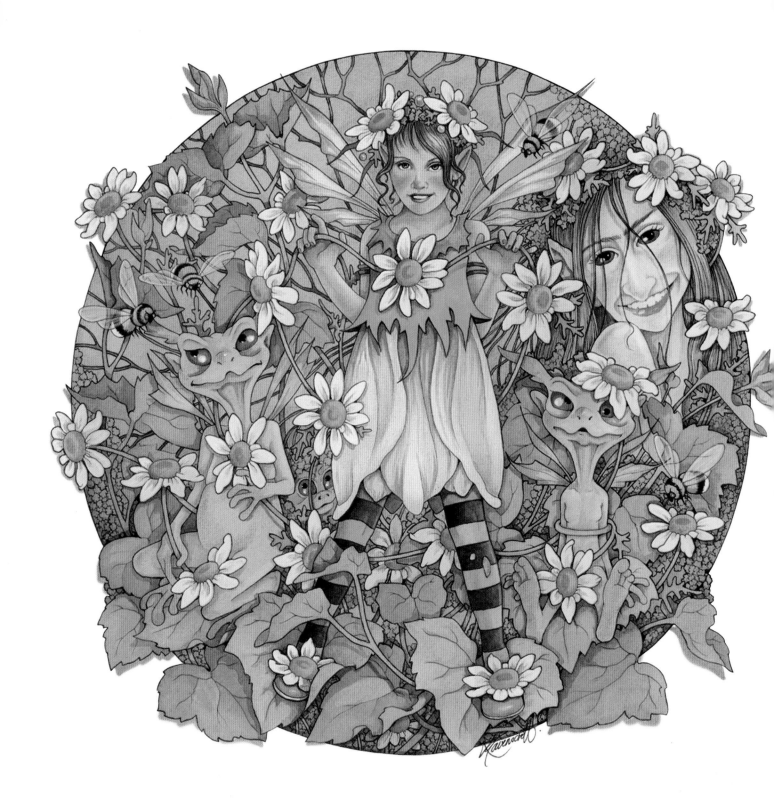

Chapter Four

# Choosing your Fairy Type

# FAIRY CHARACTERS

The paintings on these and the following two pages have been chosen to show a variety of different fairy types, with characteristic features, facial expressions, clothing, and settings. Just like humans, no two fairies are alike, and it is important to build up a complete picture of your subject's personality and create a sense of mood.

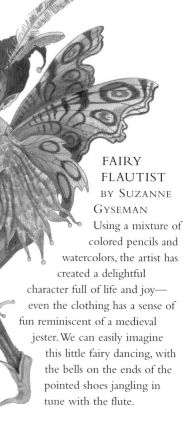

FAIRY FLAUTIST BY SUZANNE GYSEMAN
Using a mixture of colored pencils and watercolors, the artist has created a delightful character full of life and joy—even the clothing has a sense of fun reminiscent of a medieval jester. We can easily imagine this little fairy dancing, with the bells on the ends of the pointed shoes jangling in tune with the flute.

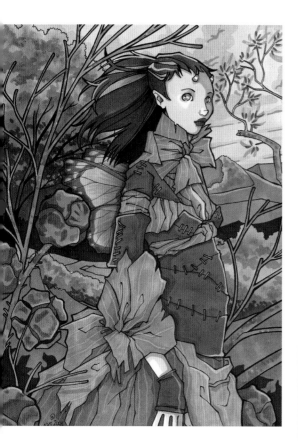

SHEER WATER IN HER EYES BY NATALIA PIERANDREI
The colors, soft muted tones of grays, browns, and blues, create a strong impression of sadness and loneliness, perhaps even a loss of something treasured. The bare foliage in the background enhances the effect, and the fairy's gown, crudely sewn and patched, gives the impression of hard times—this is clearly not a happy fairy.

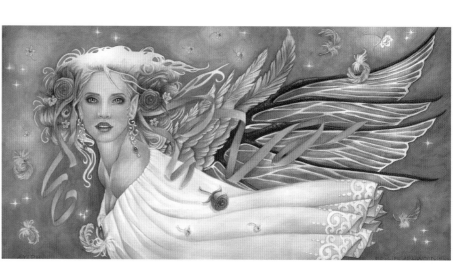

SYLPH BY BRIGID ASHWOOD
A sylph is a fairy of the air, and the artist has expressed this idea by creating an almost angelic, serene fairy who appears to be blown in a gentle breeze, with the flowing ribbons and feathers emphasizing the sense of movement. Very soft washes of watercolor in pale tones maintain the delicacy of the image.

## THE BUBBLE FAIRY

BY SUZANNE GYSEMANN
Just like human children, fairies can't resist playing with soap bubbles, and this charming little character is obviously having a great deal of fun. The drawing, in ordinary graphite pencil, shows how much can be achieved with the most basic materials and the minimum of detail.

## THE NOTHING TO DO FAIRY

BY LINDA RAVENSCROFT
Even fairies can get bored, and this character has a distinctly teenage look. The simple cameo image, with little going on in the background, allows the viewer to concentrate on the main fairy character. The painting was done in watercolor over an ink drawing, with salt spatter used to create a crystalline effect on the wings.

## FIONA AND THE SWAN

BY MARCEL LORANGE
This painting conveys the deep and caring relationship between the fairy and the swan, and they appear to be completely at one with each other. The artist has given a lovely ethereal feeling to the image through clever use of thin acrylic paint.

## FORGET-ME-NOT FAIRY
### BY LINDA RAVENSCROFT

Fairies make use of the plants and flowers around them for many things, including their clothing, and this fairy is named for her own flower, the forget-me-not, whose petals she uses even for the little flowers that adorn her shoes and hair. This is a typical childlike fairy image, painted in watercolors over an ink drawing.

## ELFIN AJA BY GARY A. LIPPINCOT

This lovely watercolor shows both the artist's delight in nature and the fairy's equal delight in the tiny fairy figure perched on the end of her finger. Full of intriguing detail, this is the sort of painting that shows the viewer something new every time—there are so many individual fairy beings within the composition that it's hard to count them all.

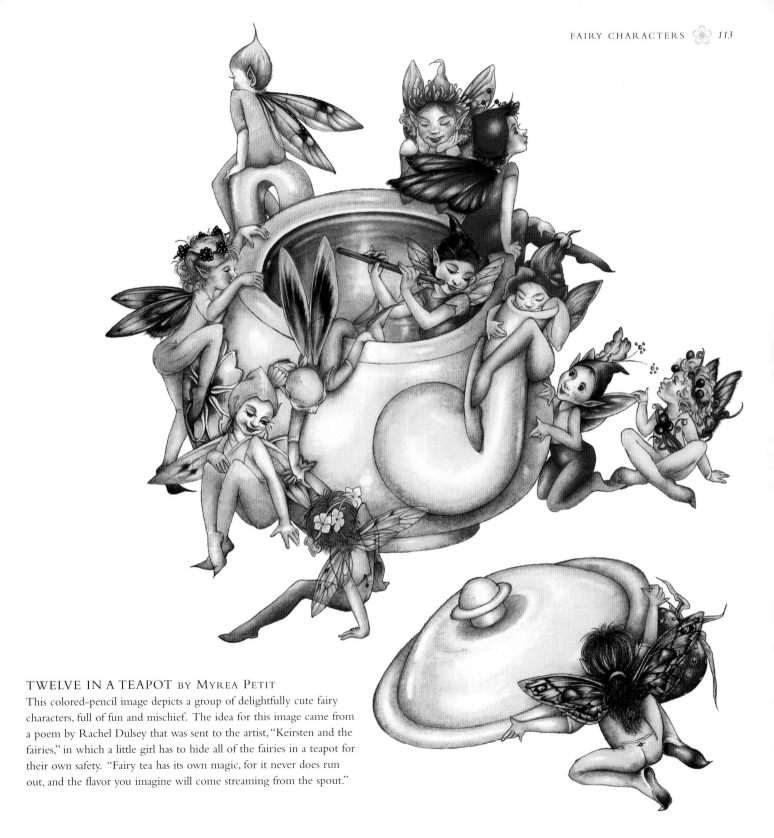

## TWELVE IN A TEAPOT BY MYREA PETIT

This colored-pencil image depicts a group of delightfully cute fairy characters, full of fun and mischief. The idea for this image came from a poem by Rachel Dulsey that was sent to the artist, "Keirsten and the fairies," in which a little girl has to hide all of the fairies in a teapot for their own safety. "Fairy tea has its own magic, for it never does run out, and the flavor you imagine will come streaming from the spout."

# FAIRY TALES

Most of us were told fairy tales when we were young children—magical stories of children who could fly and animals who could talk—and hopefully this selection of images will reawaken your childhood memories and stir your imagination. You might also try rereading the classic fairy stories.

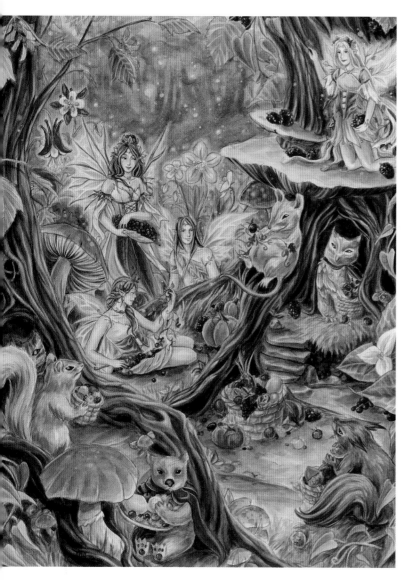

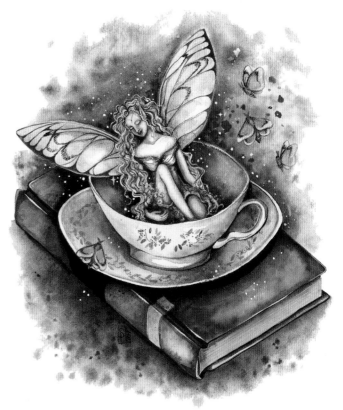

### TIME FOR TEA BY
### SARAH PAULINE

This little fairy is just about ready for bed, and what better way to relax than with a nice cup of tea and a good book. The image was painted with watercolors and ink, and the artist has included some moths and sprinkles of stardust using white opaque paint, which helps to give the impression of night-time and sweet dreams.

### GUESTS AT THE GOBLIN FEAST
### BY MEREDITH DILLMAN

This colorful scene has almost everything a fairytale should have. The fairies are preparing a feast among toadstools and tree roots, with numerous woodland animals sharing the fruits collected from the forest. Notice that some of the animals are wearing clothing, giving the impression that they have humanlike qualities and are probably able to talk.

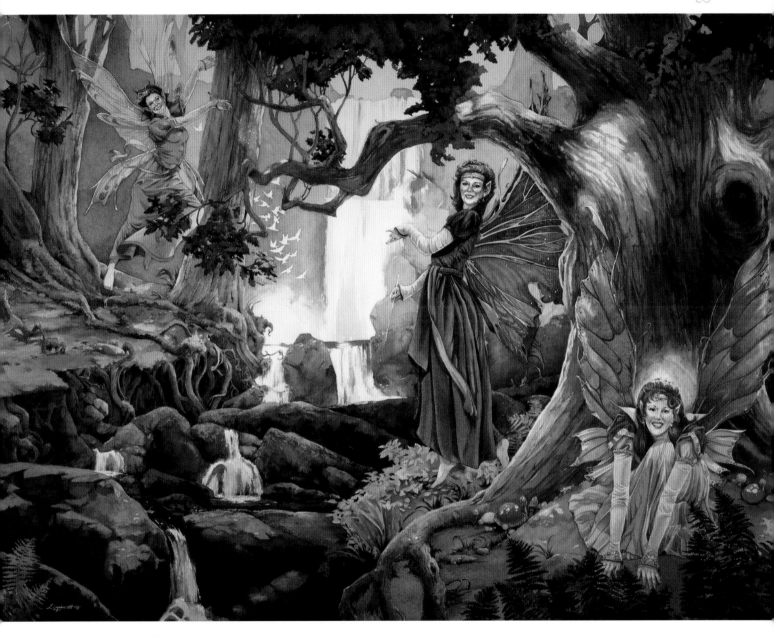

## FAIRY GODMOTHERS BY GARY A. LIPPINCOT

Everyone longs for a fairy godmother, especially if she looks like these three, with their wonderfully warm smiles and obvious magical abilities. The painting is in watercolor, with the forest trees, rocks, and magic waterfall depicted with great care and attention to detail.

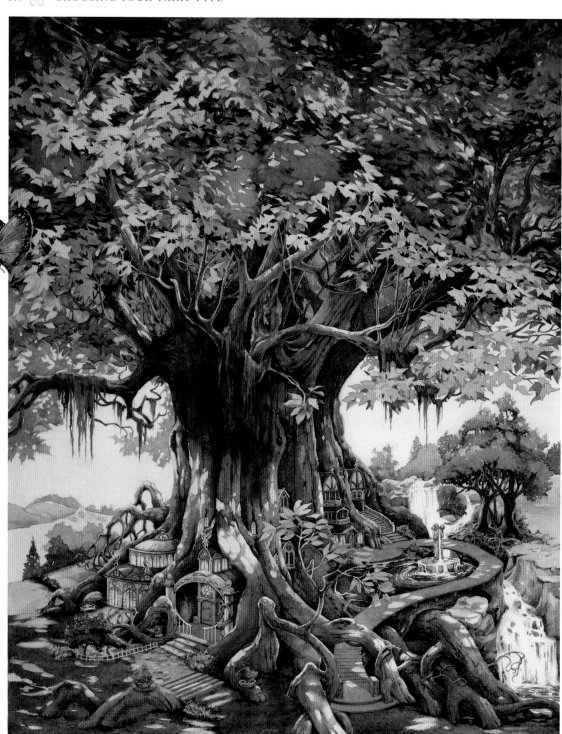

## EARTH MOTHER
BY GARY A. LIPPINCOT

A magical tree set in a lush green landscape, protector and "earth mother" of the fairies who live between its roots, this is a superb example of a fairy tale landscape. Look closely and you can see so much going on in this scene: intricate little windows, stairways, and miniature gardens complete with plant pots and flowers. Watercolor has been used with great skill throughout this painting, but notice in particular the way that the artist has reserved light green on the foliage and beneath the tree to create the impression of dappled sunlight.

## AWAKENING OF FAE BY STEVE FOX

This is a wonderful image showing how fairies might be seen by humans. The young woman, surrounded by a bright, glowing aura of fairies, is spellbound by what she can see. Among the rainbow of lights you can just make out the fairy figures flying up into the sky, painted so that they almost disappear into the background to give them a more magical appearance.

## WISE OLD OWL

BY LINDA RAVENSCROFT

"The wise old owl who lived in the oak, the more he heard the less he spoke, the less he spoke the more he heard, why can't we all be like that wise old bird?" The artist's interpretation of this old verse is a little more contemporary, and the owl is shown as part of the oak tree, which is said to be the wisest and oldest of trees. This is a mixed-media painting using acrylic for the background with a watercolor wash over the top.

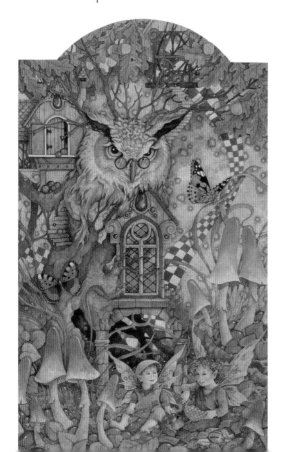

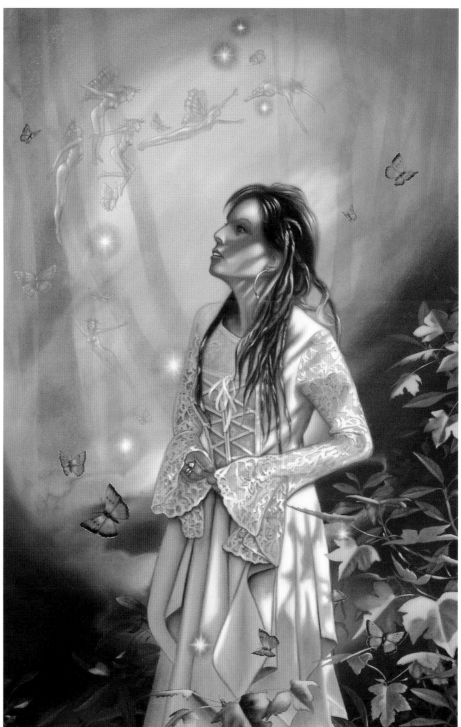

# ELEMENTAL FAIRIES

Fairies are a part of nature and the world around them, and the four elements—air, water, fire, and earth—are among their natural places of belonging. Some fairies have characteristics that identify them as elemental fairies, for example, sylphs fly through the air, nymphs can often be found in water, and fairies associated with the earth element may be seen tending plants and flowers.

### ALYANA
#### BY JACQUELINE COLLEN-TARROLLY
This is an air-dwelling fairy, and naturally the wings are of major importance. The artist has stressed this by giving the fairy a tiny body in relation to her wings, but these appear fragile and gossamerlike rather than heavy. The intricate designs on the wings are similar to those on the feathers of a peacock, perhaps in order to suggest the idea of beauty and pride, a theme that is echoed in the peacock butterflies that surround the figure.

### WATER NYMPHS BY ED HICKS
This lovely pastel drawing depicts two water nymphs bathing on a hot summer's day. The figures are larger than most fairies, and could almost be human if it were not for the wings, and the countryside setting has been drawn very realistically, probably from a real-life view. This is a good example of how the things you see around you can be used as an integral part of your fairy paintings and drawings.

## THE RED FAE BY LINDA RAVENSCROFT

This fairy combines the characteristics of a fire-element fairy with those of an autumn fairy, and the artist has chosen a palette of suitably hot colors. The Red Fae is the fairy that dries out the lush green leaves on the trees, causing them to turn to red and gold before falling to the ground, and this fairy is a little on the naughty side. The background was painted in acrylic, and the fairy in watercolor over an ink drawing.

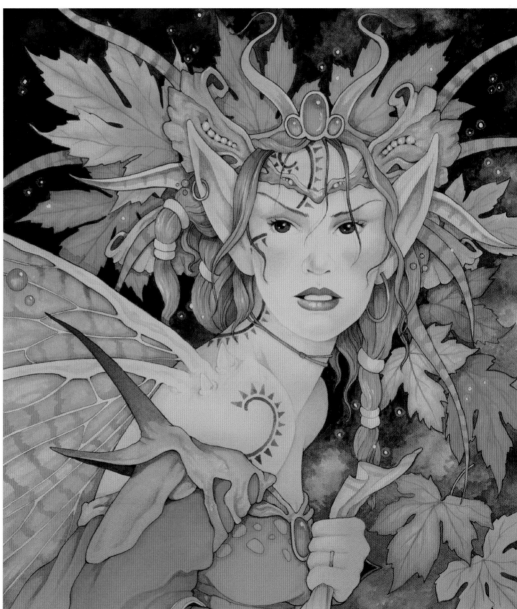

## LISTENING TO MOUSE
## BY ED HICKS

This charming image has been drawn with pastels on gray paper, which has provided the background color. The fairy is strongly identified with the element of earth, and is shown caring for flowers and at home with small animals.

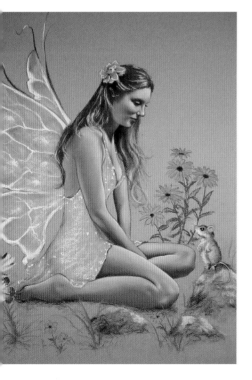

# FLOWER FAIRIES

Fairies of flowers and plants are among the most beautiful tribes of the fae. These fairies are usually graceful and delicate, and often take on characteristics from the flowers and plants they inhabit, sometimes using their petals and leaves to clothe themselves. Look around parks and gardens to find flowers on which to base your fairy paintings, or draw inspiration from garden catalogs and botanical books.

### GUELDER ROSE
BY LINDA RAVENSCROFT

The guelder rose, not actually a rose but a delicate spray of little white blossoms, was once a common wildflower, but sadly is becoming more and more scarce. The fairy's wings give the image an impressive air, and help to make the figure stand out against the delicate flowers and green leaves.

### PLAYING IN THE WIND
BY W. SKJONDAL

In this lively and exciting watercolor, the artist has captured the spirit of the tiny fairies playing with the delicate petals as they are blown off the peony flowers. Or perhaps they are actually pulling them off—fairies can be quite mischievous at times.

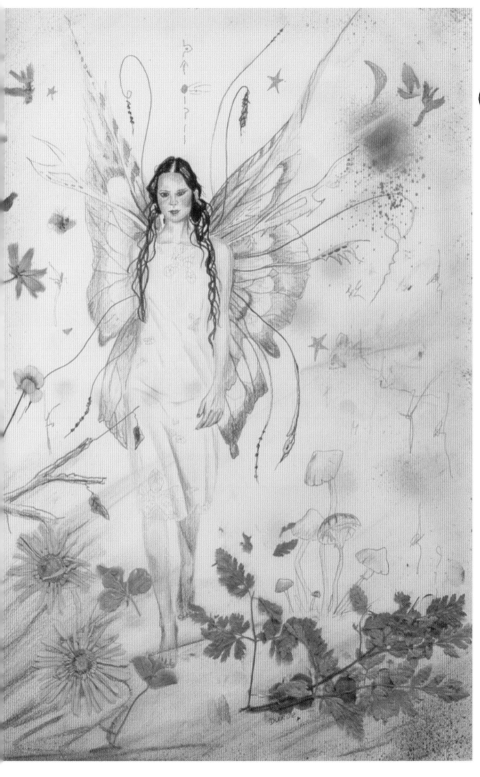

## MUSHROOM CUP
### BY KATE DOLAMORE
This cheeky little fairy with pretty blue
violets was painted in watercolor,
gouache, and inks. The artist has used a
wash of dark green watercolor for the
background, creating a natural frame
for the painting, but has taken parts of
the image over the edges to break up
the rectangular shape.

## AUTUMN FAIRY
### BY ANDREW DUROE
An unusual combination of watercolor and
collage has been used for this image, with
stuck-on dried flowers and foliage giving a
lovely organic feel. The figure has been treated
softly so that it merges into the composition
rather than overpowering it.

# SEASONS' HERALDS

The cycle of the four seasons, like the four elements, provides inspiration for many fairy artists. Each season can be suggested by the choice of colors as well as the characteristics of the fairies themselves, with winter fairies typically being more somber in mood than those associated with spring and summer.

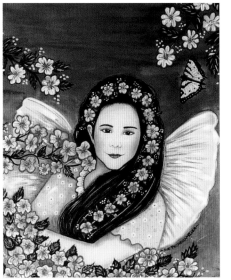

## BUTTERFLY FAIRY BY ED HICKS

This image, in pastel on cream paper, gives a feeling of summer, the season of butterflies. The effect of the gossamer gown—perhaps spider silk—was achieved by completing the figure first, and then applying white pastel over the top to create the fabric folds and lace effects.

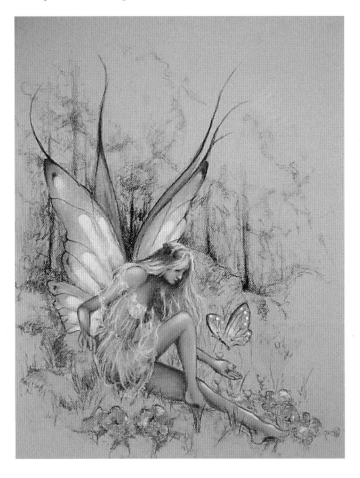

## AUTUMN SPRITE
### BY MEREDITH DILLMAN

A typical autumnal palette has been used for this fiery little sprite painted in watercolors over an ink drawing. The spiky leaf shapes used for the wings give an excellent feeling of the season, as do the swirling leaves at the bottom of the image, which also act as an oval frame to hold the composition together.

## GARDEN
### BY SUE MILLER

Springtime blossoms feature prominently in this painting, and the fresh colors of the fairy's face give a feeling of youth and vitality. You can sense the growth and renewal so vital to a garden after the long winter months.

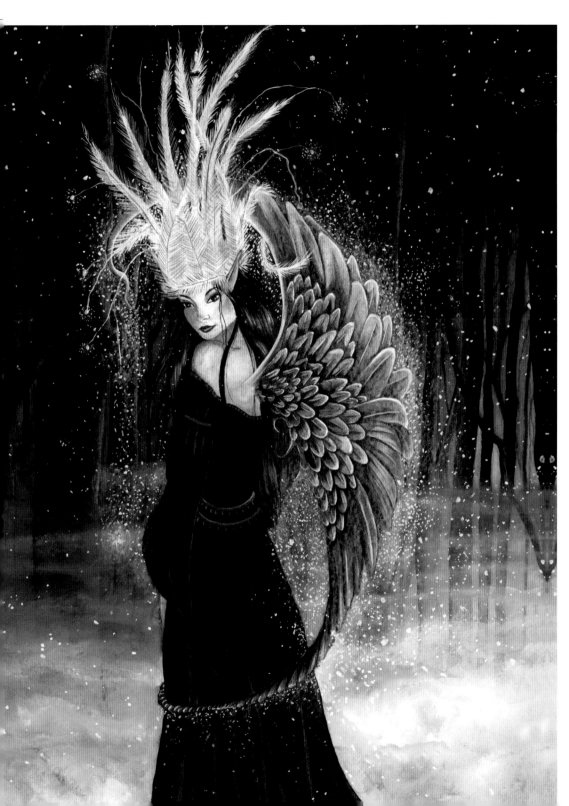

## QUEEN OF THE FOREST
BY MICHELLE CAMPBELL

This powerful but ethereal wintertime image was painted with watercolor and gouache. The use of strong tonal contrasts—midnight blues and pure frosty white—creates a perfect balance, and the darkness of the forest allows the icy white feathers of the headdress to show up perfectly. White gouache was used to add small sprays of snow and ice crystals all around the figure.

# MAGICAL FAIRIES

Magic is the essence of the fairy world, and although it can't be seen there are ways of suggesting it in your paintings, as these images show. Believe in it strongly enough, and you may find a little fairy magic rubs off on you and helps you to create your own.

### MAGFLOG BY ANDREW DUROE
This painting is full of magic and mystery, with the huge moon taking over most of the background to give a wonderful atmosphere and sense of space. The fairy seated on the magpie is set slightly off center to the left-hand side of the painting where the moon is lightest, creating a semi-oval shape that helps to lead the eye to the figures, and we then follow the curve of the moon to the fairy tale castle in the background.

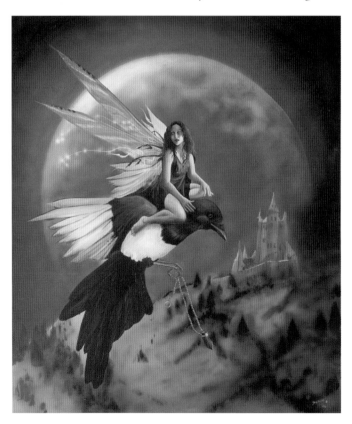

### LUNA
BY MEREDITH DILLMAN
This fairy character represents the moon, which as we all know has its own mystical influences and powers. She is seen holding a magical staff with a silver crescent-shaped top to symbolize the new moon, and her wings and gown are covered in tiny white specks of paint to give a starlike sparkle that reinforces the night sky effect.

### A PERFECT SPHERE
BY LINDA RAVENSCROFT
Some fairies have the gift of prophecy and foresight, and are able to gaze into the sphere to see what the future holds. This painting, though, has a double meaning—the perfect sphere could be either the moon or the crystal ball held in the fairy's hands, and both have been shown similar in size to create an enigmatic image.

## FAIRIE AWAKENING
### BY SUZANNE GYSEMAN
Colored pencils have been used to create this soft, atmospheric image, in which the idea of magic is suggested by the moon and the aura around the little fairy. The pale areas, including the figure and parts of the wings, were achieved by working very lightly and then building up around them with darker shades, creating a soft glowing light effect that is perfect for fairy pictures.

## KINDRED BY MATT HUGHES
The angel and the fairy, seemingly related in some way, as the title suggest, are both gentle winged creatures with magical powers. Here you can see two types of wings, one very birdlike made with soft white feathers and the other more akin to that of a dragonfly.

## THE BUTTERFLY FAIRIES
### BY HAZEL BROWN
The artist made careful studies of the peacock butterfly for her fairies' wings, and painted them in great detail. And then, as if by magic, the butterflies evolved into these tiny fairy folk, happily flitting around their fairy ring—perhaps fairies and butterflies have more in common than we think.

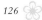

# INDEX

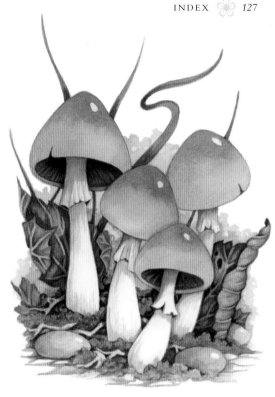

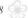

# CREDITS

Quarto would like to thank the contributing artists for kindly supplying illustrations reproduced in this book.

Artists are acknowledged beside their work. All other photographs and illustrations are the copyright of Quarto Publishing plc. While every effort has been made to credit contributors, Quarto would like to apologize should there have been any omissions or errors—and would be pleased to make the appropriate correction for future editions of the book.

All other illustrations are the copyright of Linda Ravenscroft or Quarto. Any illustration not credited to an artist on the page where they appear are the work of Linda Ravenscroft, who can be contacted at www.lindaravenscroft.com or by email at linda@ravenart.fsnet.co.uk.

## AUTHOR'S ACKNOWLEDGEMENTS

### DEDICATION

To my fairy model and daughter Vivien Louise, and in memory of Little Charlotte who will always shine brightly in our hearts.

Special thanks to my long-suffering husband John; Mum and Dad, my best critics; Master Matthew Price, Vivien and Lawson Price, Anne and John Ravenscroft, and Cath and Paul Kelly for their encouragement over the years.

Thanks also to Dave and Myrea at Fairies' World; Angi, Merni and Silas at the Duirwaigh Gallery; my wonderful adult models: Sally Huxley and Emma; artists Brian Froud and Alan Lee for offering inspiration, hope and a belief in all things magical. Last, but not least, all my loyal fans and fairy believers.

Shine brightly and live your dreams.

## ARTISTS' WEBSITES

Brigid Ashwood
www.ashwood-arts.com

Hazel Brown
www.faery-art.com

Michelle Campbell
www.faerywoods.com

Jaqueline Collen-Tarrolly
www.todstoolfarmart.com

Meredith Dillman
www.meredithdillman.com

Kate Dolamore
www.pencilshavings.com

Andy Duroe
www.fairydome.com

Steve Fox
www.gothicangel.co.uk

Suzanne Gyseman
www.suzannegyseman.co.uk

Ed Hicks
www.thefairykingdom.com

Matt Hughes
www.matthughesart.com

Gary A. Lippincot
www.garylippincott.com

Marcel Lorange
www.lorange-art.com

Sue Miller
www.suemillerart.com

Sarah Pauline
www.fortryllelse.com

Myrea Pettit
www.fairiesworld.com

Natalia Pierandrei
www.nati-art.com

Linda Ravenscroft
www.lindaravenscroft.com

Wenche Skjondal
http://wenche.skjondal.net